ST ANDREWS PUBS

GREGOR STEWART

AMBERLEY

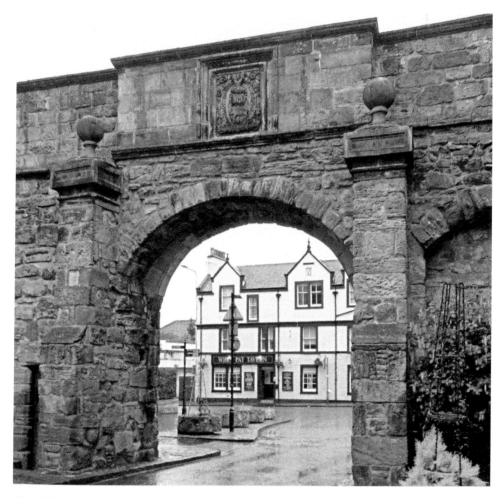

The Whey Pat Tavern looking through the historic West Port.

First published 2017

Amberley Publishing
The Hill, Stroud
Gloucestershire, GL5 4EP

www.amberley-books.com

Copyright © Gregor Stewart, 2017
Maps contain Ornance Survey data.
Crown Copyright and database right, 2015

The right of Gregor Stewart to be identified as
the Author of this work has been asserted in
accordance with the Copyrights, Designs and
Patents Act 1988.

ISBN 978 1 4456 6504 7 (print)
ISBN 978 1 4456 6505 4 (ebook)

British Library Cataloguing in Publication Data.
A catalogue record for this book is available from
the British Library.

Origination by Amberley Publishing.
Printed in the UK.

Contents

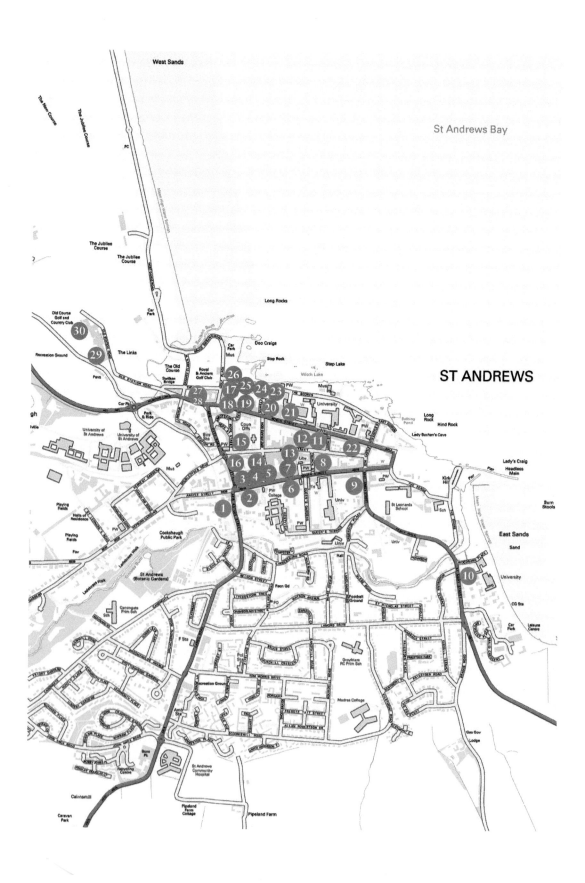

Key

1. The Whey Pat Tavern
2. The West Port Bar & Kitchen
3. Drouthy Neebors
4. The St Andrews Brewing Co.
5. Aikmans Bistro and the Cellar Bar
6. The Rule
7. The Adamson Bar
8. The Criterion
9. The Café Bar
10. The New Inn
11. The Central Bar
12. The Keys Bar
13. Forgan's
14. The Vic
15. The Student's Union
16. The Blue Stane
17. No. 1 Golf Place
18. The Dunvegan Golfers Corner
19. Playfairs Bar
20. Greyfriars
21. Rascals
22. The Beer Kitchen
23. The Russell Hotel
24. Ma Bells
25. Chariots
26. Hams Hame
27. The One Under
28. The R Bar
29. The Jigger Inn
30. The Road Hole

Introduction

The town of St Andrews, situated in north-east Fife, Scotland, is known worldwide as the Home of Golf, a game that is synonymous with the 19th hole, the nickname given to the drinking establishments players visit for some liquid refreshment after a round of golf. It is therefore not surprising to hear that St Andrews also has more than its fair share of pubs to cater for locals, visitors, students and golfers alike.

The origins of St Andrews can be traced back to the Pictish times, when a Greek monk named Regulus was said to have been shipwrecked against the cliff below the town. Regulus was carrying with him some of the remains of the apostle St Andrew and, having been granted land to establish a religious centre, the town was born. With weary pilgrims travelling from all over the country believing that the bones of St Andrew could perform miracles, breweries and pubs were soon established to cater for the needs of the travellers. The growth of the university, founded in 1413, brought more people to the town, and resulted in more taverns with rooms to let cropping up. The religious reformation ended St Andrews' status as a religious powerhouse and the town fell into decline, until the growth in popularity of the game of golf, which grew from its humble origins in St Andrews over a century earlier. One of the first records about golf gives an insight as to how the game affected the country. Fearful that his armies no longer had sufficiently skilled bowmen due to more young men taking up golf rather than archery as a pastime, in 1458 James II made the playing of golf an offence against the state, instead decreeing that every Sunday the men must set up a target and fire at least six arrows. Anyone failing to do so was to pay a fine of 2d, with all fines being split between those who had practised archery to allow them to buy drinks. Needless to say, in St Andrews many defied the ruling and continued to play golf and paid their fines, with this being possibly the earliest connection between the game of golf and enjoying a drink, or the 'winner' buying everyone else a drink.

With successive kings failing to stop the ever-increasing number of people playing golf rather than taking up archery, attempts to ban the game were abandoned, and thanks in part to a golfing competition replacing an archery competition in St Andrews, the town established itself as the golfing capital of the world. With prosperity returning

James Boswell and Samuel Johnson

This is the site of Glass's Inn, 29 South St where Boswell and Dr Johnson had supper on 18th August 1773.

"We had a dreary drive, in a dusky night, to St Andrews where we arrived late. We found a good supper at Glass's Inn, and Dr Johnson revived agreeably... ...After supper, we made a procession to Saint Leonard's College, the landlord walking before us with a candle, and the waiter with the lantern."

(James Boswell, Journal of a Tour to the Hebrides with Samuel Johnson, 1785)

The Inn existed until at least 1830.

Erected by the St Andrews Preservation Trust Gordon Christie Bequest

Plaque at the site of the Black Bull Inn.

to the town, the breweries and pubs re-established themselves to serve the growing population and visitors.

The pubs of St Andrews were also used as meeting places for officials and visitors, the oldest being Baillie Glass' Inn, which stood on South Street. This was where golfers used to hold their meetings prior to the establishment of the golf clubs, and was where the lawyer and biographer James Boswell dined with the writer Dr Samuel Johnson in 1773. The two men had become good friends and after the death of Dr Johnson in 1784, Boswell would go on to write the biography *The Life of Samuel Johnson*, published in 1791 and deemed by many to be one of the best biographies ever written. Baillie Glass' Inn is also where a group of twenty-two noblemen, known collectively as The Society of St Andrews Golfers, would meet from 1776 onwards for food and refreshments after their fortnightly round of golf. The society had been founded in May 1754 through the creation of a new golf competition, 'The Silver Club', and was pivotal in establishing St Andrews as the Home of Golf. Baillie Glass' Inn continued to be used for society meetings and functions until the site was redeveloped in 1830 (the pub was trading as the Black Bull Inn at that time). They also used the Cross Keys Hotel, which will be discussed later in this book, prior to moving to their new purpose-built golf club, the Royal and Ancient, in 1854. It is perhaps difficult to imagine that one of the most famous and most photographed buildings in the world grew from fortnightly meetings in a local pub.

Several drinking traditions have arisen in St Andrews, mostly associated with the university, probably the most famous of which is the Raisin Weekend. Although this will be mentioned again later in the book, this is a custom whereby older students 'adopt' first-year students to become their academic parents, to guide them through university life. One of the first get-togethers is a tea party, although it is not so much tea being drunk but alcoholic drinks, and a pub-crawl around the town finishes off the night. The Raisin Weekend takes its name from new students originally giving their academic parents a pound of raisins as a gift, although a bottle of wine is now the preferred offering. The May Day Dip is another annual ritual for students of the university, when, often after a whole night of drinking for Dutch courage, the students meet on the beach of the East Sands at sunrise on 1 May and run into the ice-cold waters of the North Sea to wash away all their mistakes of the past year.

What is unusual about St Andrews is that despite the rapid post-war growth of the town, the bars did not follow the housing schemes of the new suburbs and predominantly remain firmly within the boundaries of the medieval centre. Today, the town has a wide range of pubs, from the traditional to the contemporary, providing the facilities to meet the needs of modern-day life. Yet almost all are situated in historic buildings that retain the character and the appearance of the town. These pubs are where you will find locals, students, visitors and sometimes the rich and famous, or even royalty, happily mixing and enjoying a relaxed drink in each other's company.

I

The Historic Town Centre

The town of St Andrews can trace its history back for more than a century when, as mentioned in the introduction, it is said a Greek monk named Regulus was shipwrecked in St Andrews Bay. He was carrying relics of the apostle St Andrew with him, from which the town eventually took its name. In 1123, St Rule's Church was built (St Rule being an alternative name to St Regulus) to cater for the growing religious importance of the town, and by 1162 work had started on the construction of the great cathedral, the largest church in Scotland, which became the centre for the Catholic faith in Scotland. This brought pilgrims from all over the country to the town, which had to grow to cater for the influx of visitors, many of whom chose to stay, causing the town centre to spread further.

Growing tensions between England and France had started to make it dangerous for the religious sector to travel to either country to study, so the University of St Andrews was established to provide the required education facilities. Having been founded in 1413, St Andrews University was the first such establishment in Scotland and is the third oldest in the English-speaking world. That in itself brought more people to St Andrews, and increased demand for facilities to cater for the growing population's needs.

As the town grew, three main streets fanned out from the cathedral: North Street to the north, South Street to the south, and Market Street in the centre. The Town House and Tollbooth Jail were both situated in Market Street, which became not only the market place in the town, but also where public punishments were carried out. Lammas Day was a tradition in Scotland, with freshly baked loaves of bread being brought to the church on the 1 August to be blessed in celebration of the first day of the harvest. With St Andrews being the head of the church, this was a big day for the town and the Lammas Fair grew with stalls in Market Street.

The religious reformation in the sixteenth century saw destruction come to St Andrews, with all Catholic establishments being ravaged, including the cathedral and Archbishop's Castle. With the end of the religious reign in the town, the population fell and, as a result, the town started to fall into a state of decline. It was

the start of a downwards spiral, with people leaving to find work elsewhere resulting in less demand for the few businesses that remained and their eventual closure. The university managed to survive, despite attempts to move it to Perth in response to the decline of the town. The only industry that remained was fishing, and the town centre buildings started to decay. All this was reversed when golf became established in the town again. The competitions brought people, which resulted in hotels and pubs reopening to cater for the visitors. Some chose to stay, realising that a grand town house in the centre could be bought for considerably less than the likes of Edinburgh. The student population started to grow again, creating more demand for places to eat and drink in the town and the fishing slums were demolished, making way for new buildings suitable for the renewed wealth of the town. Rather than build an out-of-town campus, as many universities do, St Andrews University started to utilise the redundant buildings in the town centre, bringing new life and further regeneration to the town.

Today you can still wander through the medieval streets and through the ruins of the cathedral. The oldest surviving complete building is believed to be Dean's Court, a fifteenth-century house, now used as accommodation for postgraduate students. This is closely followed in age by sixteenth-century buildings – the Roundel, which sits beside Dean's Court, and Queen Mary's House, the residence where Mary Queen of Scots stayed while visiting the town. Other traditions continue as well, such as the annual Lammas Fair, which comes to town on the second Monday in August, although the market stalls and fair rides are set up the week before in Market Street. Even though many of the university faculties moved into the historic buildings in the town centre, as have the pubs, don't be fooled. When you walk through the doors of one of these nineteenth-century buildings in the heart of St Andrews, you are as likely to find yourself in a sleek, modern pub with a DJ blaring out music as you are to find yourself in a traditional, old-fashioned bar.

The Whey Pat Tavern, Bridge Street

The Whey Pat Tavern sits on Bridge Street, directly opposite the West Port, one of the very last examples of a medieval city gateway remaining in Scotland. The location is significant in the pub's history, as a public house is believed to have stood here since 1580, replacing a twelfth-century establishment close by. For centuries the town of St Andrews attracted travellers, originally religious pilgrims seeking to witness the miracles the relics of St Andrew were thought to bestow, and later from other religious establishments in the area to visit the grand cathedral. These weary visitors needed a place to rest before reaching their final destination, and the hostelry was established outside the city gates to serve this cause. It is believed that the refreshment offered was a bowl of gruel, and no doubt a mug of ale.

The present building dates back to 1902; however, older maps show an earlier public house on the same site, also named the Whey Pat. The name of the pub is derived from the early days of the first hostelry on the site, with the term 'Whey' referring to the type of gruel served to the pilgrims, and the 'pat' being the name given to the bowl, or pot, in which it was served.

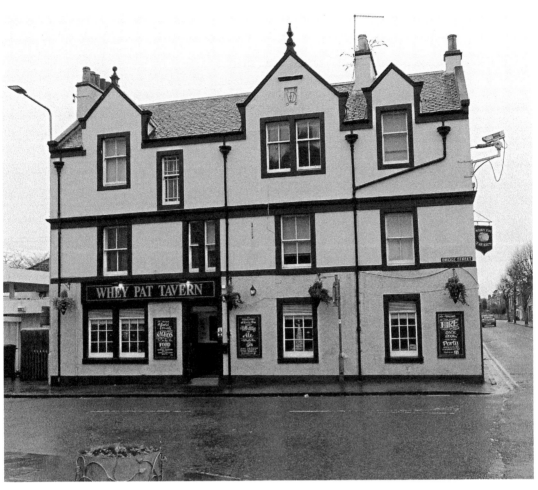

Above: The Whey Pat Tavern.

Right: The Whey Pat sign showing the bowl of 'gruel'.

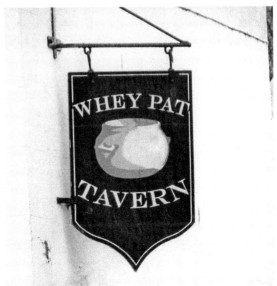

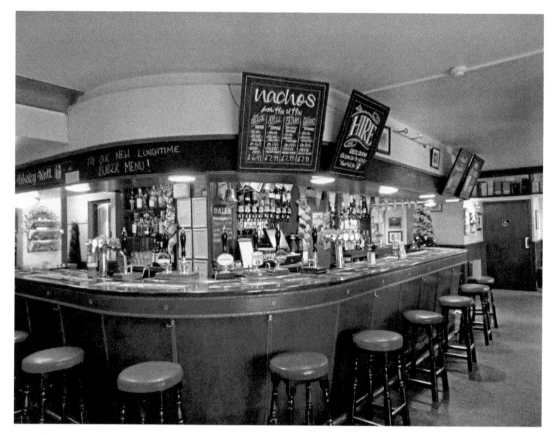

The bar area.

In 1952 the pub hit the local news for an unusual reason when the publican, Stewart Pairman, taught his canaries to sing in the bar. It was noted that Mr Pairman had already won several trophies that year for his canaries. Today, the singing on offer is from the more traditional method of folk bands and performers with a regular music night, and other time-honoured customs associated with a pub are still on offer, such as darts and dominos. Although the pub is popular with local residents, a dominos competition named 'The Town and Gown Dominos Duel', where the university staff and students compete against the regulars, also helps to link the pub with the students.

Behind the bar a range of up to seven ales are served, which are rotated on a regular basis to attract the real ale drinkers. Around sixty whiskies are also available, along with the other spirits, beers and wines. The pub is also still popular with visitors to the town, although instead of the gruel, a range of meals prepared with fresh, local ingredients can now be enjoyed.

The West Port Bar & Kitchen, South Street

The West Port Bar & Kitchen sits at the western end of South Street. The impressive building was constructed around 1870 as a hotel with bar facilities and traded for

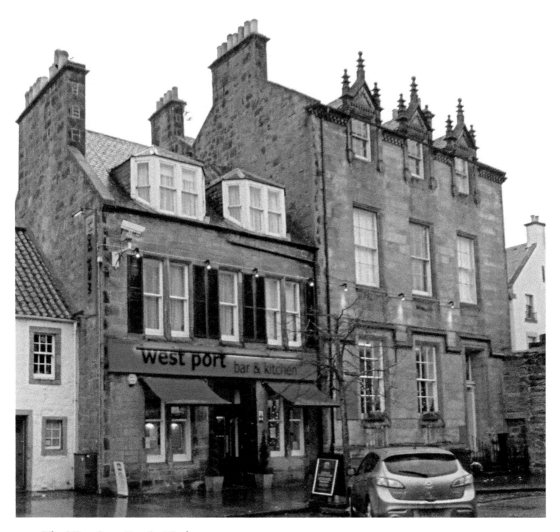

The West Port Bar & Kitchen.

many years as the Blue Bell Hotel under different ownerships. In 1950, the hotel was again sold and sometime after it changed its name to the Britannia Hotel before becoming the West Port Bar & Kitchen in the early 1990s.

I have fond memories of this bar myself from the late '80s and into the early '90s when it became a frequent early stop for my friends and myself on our regular Friday night out. At that time it was run by a lovely elderly lady, who we instantly took to. The bar was very much dated compared to others in the town, and anything other than lager was served in bottles that had rarely been near the fridge, but none of that mattered. The food on offer then was a selection of packets of crisps sat on the bar in a large 'stay-fresh' container, no doubt harking back to the days when crisps did not have the long expiry dates that we see today. Despite her age, she was not afraid to take on a bunch of young

men, and I still remember her refusing to serve one of our party a pint of lager as she thought he had drunk enough and would only serve him half a pint at a time!

The current bar takes its name from the West Port Gateway, which it stands beside. The West Port was constructed in 1589 as a monumental entrance, more for show than for defence, and is one of only two city gates still standing in the town. After falling into a poor state of repair, it was extensively renovated in 1843, with two panels being added, one depicting the city arms and the other David I on horseback. The two side arches, which are now used for pedestrian access, were also added at that time.

When the bar became The West Port, the transformation was considerable, and it moved from the old-fashioned style of the former Britannia Hotel to a modern bar with sleek and stylish finishing. The pub became very popular with students, and although it has gone through several changes since to attract more locals back, it has remained a favoured place to drink among the students. Its most famous clients were probably Prince William and Kate Middleton, who were known to select a quiet booth for meals out and a few drinks during their time at St Andrews University between 2001 and 2005.

The bar today offers comfortable, contemporary surroundings and a wide range of drinks, including a separate gin menu and a large selection of both alcoholic and non-alcoholic cocktails, with their advertising stating that they believe that 'no-one should be left out of the party'!

The bar area.

Drouthy Neebors, South Street

Drouthy Neebors is often referred to as a 'hidden gem' in St Andrews due to its location and its relatively small frontage onto South Street. Step through the doors, however, and you will find a large bar area with a warm, traditional feel.

The property at South Street was formerly an ice-cream bar and tobacconist, which was trading as far back as the start of the 1900s. More recently it operated under the 'Jannettas' name, a name synonymous in the local area with ice cream through their highly successful ice-cream shop and café at the opposite end of South Street. In the late 1980s, the premises were converted to a bar that originally traded under the name Jentrys, which became popular with the local taxi drivers for a drink at the end of their shift. It was later extended and took on the name Drouthy Neebors, which, rather

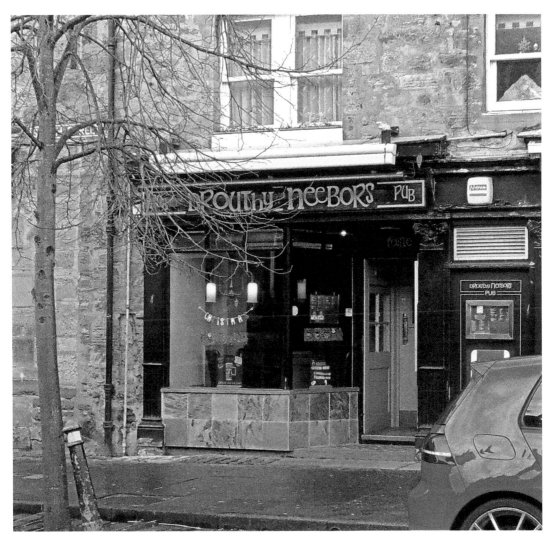

Drouthy Neebors' exterior.

than being connected to the town, comes from the opening lines of the poem 'Tam O'Shanter', by Robert Burns:

> When chapman billies leave the street,
> And drouthy neibors, neibors, meet;
> As market days are wearing late,
> And folk begin to tak the gate,
> While we sit bousing at the nappy,
> An' getting fou and unco happy

Which translates to English as:

> When the peddler people leave the streets,
> And thirsty neighbours, neighbours meet;
> As market days are wearing late,
> And folk begin to take to the road,
> While we sit drinking strong, rich ale,
> And getting drunk and very happy

The poem tells the tale of Tam, a reveller who, on his way home one stormy night on his horse, stumbles across a coven of witches in a haunted church graveyard, who give

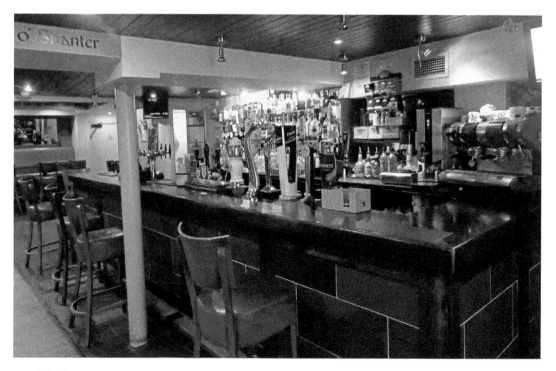

The bar area.

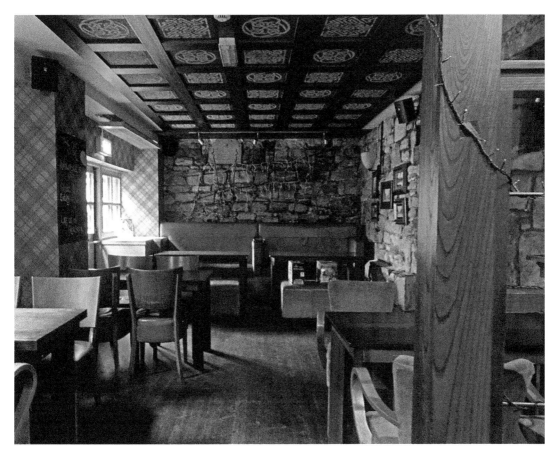

The rear seating area with painted ceiling panels.

chase with Tam narrowly escaping. It is fair to assume that the pub name relates more to enjoying a drink with friends and neighbours, as this is certainly the feel it gives, with locals, visitors, golfers and students all mingling and enjoying themselves.

Drouthy Neebors tends to be quieter during the day, being a popular stop for a pint while reading the newspaper, but at night it becomes much livelier. A wide range of beers and ales are on offer, as well as a large choice of spirits and a full wine list.

St Andrews Brewing Co., South Street

Better known as 'The Brew Pub', the St Andrews Brewing Co. premises in South Street offers something unique in the town. St Andrews has a long history with brewing, as mentioned in the introduction, with pilgrims and then visitors coming from all over to visit the town – accommodation came in the form of hotels and alehouses that were established all over the town. To meet the needs, food and drink had to be produced, and according to the book *The Penny Cyclopaedia of the Society for Useful Knowledge*, published in 1834, in the late sixteenth and early seventeenth centuries St Andrews had between sixty and seventy bakers, and as many brewers.

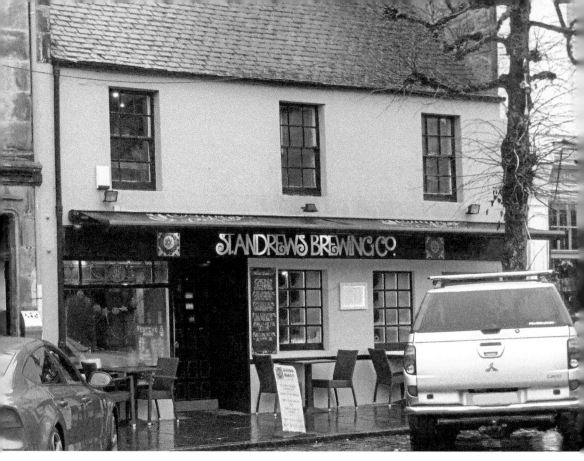

The St Andrews Brewing Co.

Over the centuries, the number of breweries declined, with the last brewer, The Argyll Brewery, closing its doors in 1901. As transport links improved, the large brewers took over supplying the pubs; however, the St Andrews Brewing Co. has set about restoring some of the traditional brewing methods in the town. Established in 2012 by former travel writer Bob Phaff, the brewery initially started production in nearby Glenrothes, before moving to St Andrews in 2014. The building in which the pub is based dates back to the eighteenth century and had operated as a restaurant for many years.

The brewery only produces 750 bottles of their beers at a time, with each one being hand brewed, bottled and labelled, and they brew every day of the week to keep up with the demand for their seven regular beers and constantly varying experimental beers.

Today, in addition to a selection of around 170 bottled beers, over thirty whiskies and bourbons, a large selection of gins and a full wine list, the bar offers sixteen ales on tap, including at least four of their own at any one time. The ales are constantly rotated, ensuring that there is almost always something different on offer, even for the regulars, and all staff are trained as Certified Beer Servers through the Cicerone Certification Program, a recognised industry standard for identifying those with significant knowledge and professional skills in beer, including flavours, styles and

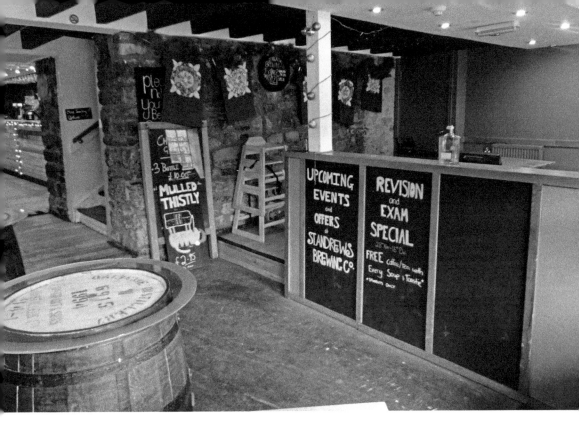

Above: The entrance area to the bar.

Below: The bar area.

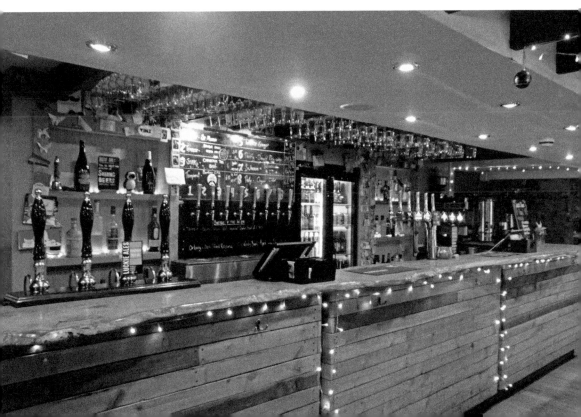

service, which allows them to offer advice on the ales to fit a specific palette. The pub has also recently joined forces with one of the best-known bakers in the area, St Andrews-based Fisher & Donaldson, re-establishing the town's connection between the bakers and the brewers. In May 2016, it was announced that they were planning to launch a 'liquid bread', based on the Dr Floyd loaf, produced by Fisher & Donaldson. This popular bread contains seven different types of seeds, including poppy, sesame and sunflower, and the brown ale that has been produced incorporates these seven seeds to replicate the distinct taste of the loaf.

Aikmans Bistro and The Cellar Bar, Bell Street

Aikmans is really two bars in one, with Aikmans Bar & Bistro occupying the ground floor, and The Cellar Bar in the basement, in a prominent listed building designed by local architect George Rae, with influences taken from Edinburgh's new town.

The name of the pub comes from a wine merchant and grocer, Aikman & Terras, which was founded in the 1830s by Andrew Aikman. Trading from a shop on the corner of Bell Street and South Street, Aikman & Terras sought to bring the finest local produce to the people of St Andrews, as well as a wide range of wines. They also

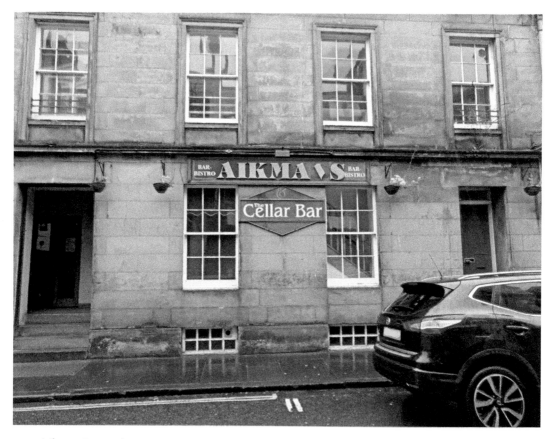

Aikman's exterior.

introduced several speciality blends of tea and coffee to the town, including their own special blend, which was exclusively prepared on the premises and sent the aroma of fresh coffee out to the surrounding streets, something that must have been quite unusual at the time. The store became a favourite in the town for its wide range of products, reasonable prices, excellent service and, of course, the range of wines and coffee, and in testament of the popularity of the business, it survived the competition from large, national supermarkets coming into the town and continued to trade until 1981. As the last reasonable-sized private grocer, there was no doubt some sadness in the town when they finally closed their doors.

Aikman's Bistro and The Cellar Bar are based in a building a very short distance from the main store, and is said to have been the former warehouse of Aikman & Terras. Established in the mid-1980s, the pub sets out to continue their tradition of good food and drink that allowed the grocers to trade for almost 150 years. Originally named The Wine Bar, Aikman's was established as a European bar, bringing wines, beers and ales from around Europe to the discerning drinkers of the town, something that it continues to do to this day.

During the day, the Bistro Bar is open and is popular with locals and visitors for a quiet drink and something to eat, while The Cellar Bar opens later in the evening, which is popular with the students, partly due to the frequent live bands that perform – it is purported that the award-winning singer K T Tunstall was a regular visitor. The pub remains one of the few independent establishments in the town, which allows it to

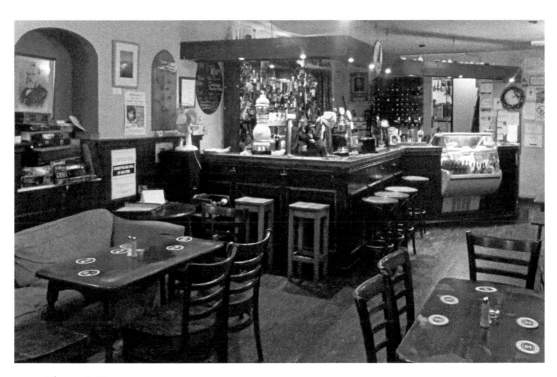

Aikman's Bistro Bar.

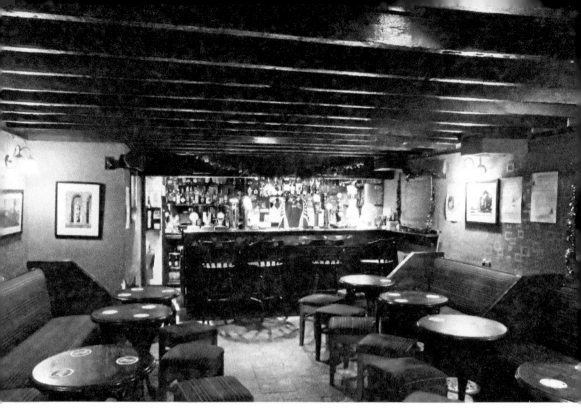

The Cellar Bar.

retain its own distinctive style. Between the two bars, a full wine list is offered, along with a wide range of whiskies, rums, vodkas and up to forty beers from across Europe. It is said that Aikman's offers possibly the widest range of drinks in St Andrews.

The Rule, South Street
The Rule is deceptively large, with the entrance giving little idea of the sizeable bar that occupies the ground floor of this historic building, which dates back to around 1840. Originally constructed as a shop, bakers have predominately traded from the property, including William Brown Bakers, David Hunter, family baker and confectioner, and then John W. McArthurs, who also ran a popular tearoom at the rear of the property. McArthurs operated from several properties in St Andrews and continued to trade from this South Street address, most recently from the front store with a pool parlour in the rear, until the late 1980s and early '90s, with the exception of a period at the end of the Second World War when they closed due to difficulty in recruiting staff.

The newspaper archives give some insight into the tastes of the St Andrews locals in the past, with Brown the Baker advertising in 1887 that they were the 'sole maker in St Andrews of the patent extract of malt digestive bread', which they claimed was 'particularly recommended by invalids and all suffering from indigestion'. McArthurs advertised in late 1939 that they would 'guarantee that their shortbread to be of pre-war quality'. The shortbread must have been popular, with McArthurs

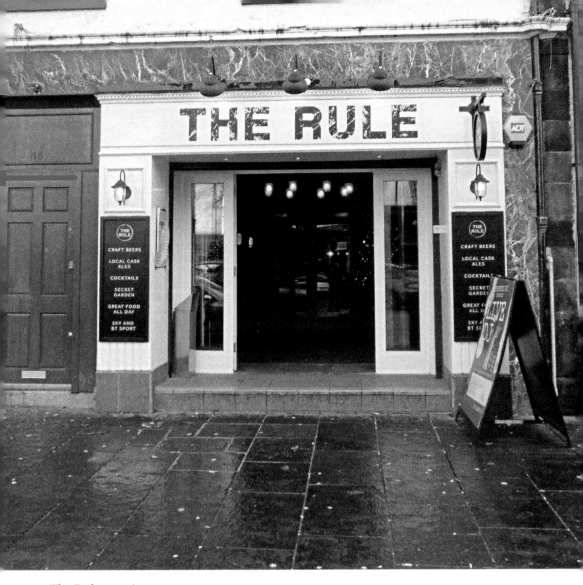

The Rule exterior.

advertising record shortbread sales in the 1950s, with orders being sent throughout the UK and abroad.

When the property was converted to a pub, it originally traded under the name 'O'Henrys', and then 'Ogstons', before changing to 'The Gin House'. It is, however, the current name 'The Rule' that has more relevance to the history of St Andrews. St Regulus, or St Rule, was the legendary monk who is said to have brought the relics of St Andrew from Patras, in modern-day Greece, to Scotland, where he was shipwrecked on the rocks in the Bay of St Andrews. Having escaped the sinking ship, St Rule and his followers were welcomed by the then Pictish king of the area, who gifted them his hunting lodge close to where they had landed to allow them to start to teach the Christian faith. From that humble lodge grew the city of St Andrews and its

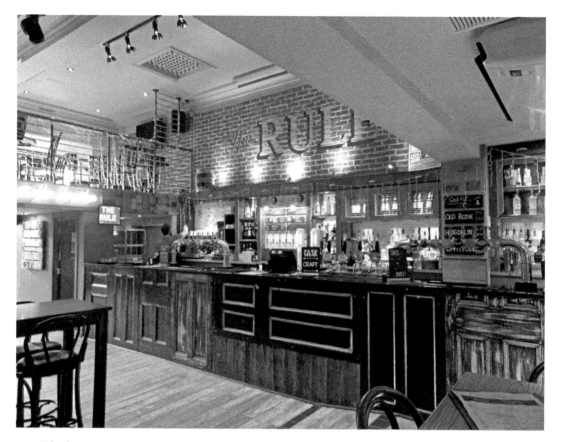

The bar area.

grand cathedral, where St Rules Tower, better known as the Square Tower, still stands as a local landmark.

The pub has been extended and refurbished several times by its various owners. It now retains a traditional pub feel but with a modern element in the form of large-screen televisions, making it popular for watching sporting events.

A small beer garden offers alfresco drinking when the weather permits. With a wide range of beers, spirits and wine, the pub specialises in craft beers, cask ales and cocktails, and is popular during the day for meals, coffees and drinks, but at night can become very busy, mainly with younger revellers.

The Adamson Bar, South Street

Although only opening as a bar in 2015, The Adamson occupies a historic building right in the heart of the medieval town centre. The building is best known as the former post office, but before that it was the home of Dr John Adamson, from whom the bar takes its name. Dr Adamson (1809–70) was a physician, physicist, lecturer, and a pioneer in early photography. He taught at Madras College in St Andrews for a number of years, and was also the curator of the Literary and Philosophical Society Museum

from 1838 until his death. However, it is his association with early photography that he is probably best known for. In May 1841, Dr Adamson, along with his associate, David Brewster from St Andrews University, produced the first calotype photograph in Scotland. This process, which involved using paper sensitised with silver chloride that reacted when exposed to light, was considered a difficult process, yet Dr Adamson was proficient in the method and taught it to his younger brother, Robert Adamson. While Robert went on to co-create the partnership Hill & Adamson, Scotland's first photographic studio, which produced several thousand photographs that are still held in high esteem, Dr Adamson remained in St Andrews to concentrate on his other work, although he continued to take photographs.

In 1907, his former home in South Street became the main post office for the town, with the upper floor being the telephone exchange. The post office operated from here until 2012, when it was sold and converted into a restaurant named The Adamson, which included a small cocktail bar. With the popularity and success of the bar growing, the business extended into the former post sorting office in 2015 to establish The Adamson Bar. The bar specialises in providing a wide range of cocktails, the signature being named 'The Physician', again in recognition of Dr Adamson. There is a large list of cocktails, as well as gins, vodkas and other spirits, along with a wide choice of wines and beers. The Adamson Bar can rightfully claim to offer something unique in St Andrews.

The Adamson exterior.

DR. JOHN ADAMSON, 1809 - 1870
LIVED HERE 1848 - 1865

HE WAS A PHYSICIAN AND PIONEER PHOTOGRAPHER.
IN 1841 HE TOOK THE FIRST CALOTYPE PORTRAIT.
HE ALSO TAUGHT HIS BROTHER ROBERT AND THOMAS
RODGER THE TECHNIQUE AND ART OF PHOTOGRAPHY.
A TOWN COUNCILLOR, HE WAS A TIRELESS WORKER
FOR PUBLIC HEALTH, AND THE HOSPITAL HERE IS, IN
PART, HIS MEMORIAL.

Above: The plaque to commemorate the achievements of Dr Adamson.

Below: Entrance to the bar.

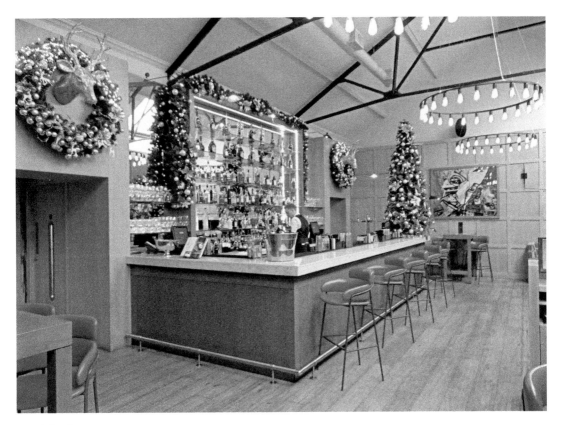

The bar area.

The Criterion, South Street

When imagining a traditional Scottish pub, what comes to mind is essentially what you will find in The Criterion. A plaque on the wall of the building proudly provides a definition of the term 'Criterion' as 'The standard by which others are judged', and adds the statement, 'After a succession of Landlords for over 200 years, this hostelry was named The Criterion in 1874'.

Although the current building was constructed in 1874, it is not clear whether a pub did stand here previously, as the plaque would seem to imply; it does, however, indicate that The Criterion name was chosen to set the pub as an example in standards for others to follow. There is, however, a bit of conflict with the summary of the history of the pub on a second plaque outside, which states 'the present building dates back to 1874. The premises were occupied by John Miller, boot maker, until the mid-1880s when a licence was issued to William John Baird for the supply of Ales and Porter only'. It is therefore clear that the building was not used as a hostelry named The Criterion in 1874, and most probably changed its use and took up the name a few years later in the mid-1880s when the limited licence was granted. A full licence was issued in 1889 to James Milne, which would have allowed the pub to serve the full range of alcoholic drinks. The business operated as a licenced restaurant

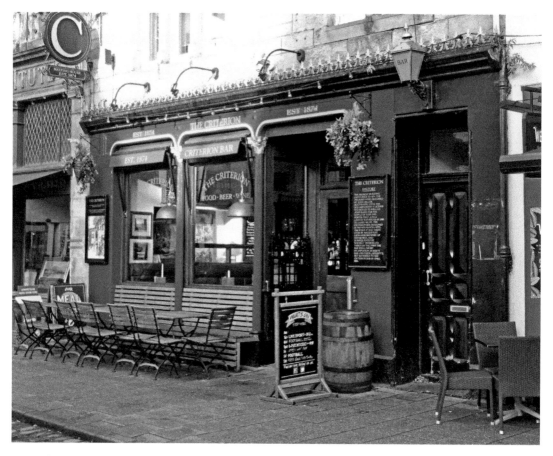

The Criterion exterior.

for much of its early years, something that may seem commonplace today, but in 1903 The Criterion was advertising in the local press stating they were 'the best and only licenced restaurant in the city', something that would seem unthinkable to modern-day visitors to the town.

The pub passed through various owners over the years, but remained in private hands until 1960 when it was taken over by G. MacKay & Co. Brewers, following their purchase of the St Leonards Brewery in Edinburgh. After briefly being renamed Bert's Bar, and then Laffertey's, the pub reverted to The Criterion in 2006, and has been extensively renovated to its former glory, with ornate wood panelling on the walls, timber floors and traditional yet comfortable seating. Many photographs of the pub from days gone by are displayed on all of the walls that give a real insight into the history, with a large picture taken during Queen Elizabeth's visit to St Andrews in 1950 as her car passed The Criterion.

While still popular with local residents, The Criterion has shaken off most of the 'old-man pub' feel it once had and is a favourite with visitors to the town. As well as the usual offerings of drinks, the elegant carved bar houses six cask ales on tap and

Close-up of the sign showing the date.

over 100 malt whiskies. The pub keeps up with traditional activities, including quiz nights and hosting live music, and also shows live sporting events. As well as offering a wide range of drinks, the food is also popular, particularly the 'Cri-Pies', which the pub claims are 'world famous', a claim they are probably entitled to make given that visitors from all over the world seem to make special visits to The Criterion just to sample one of their pies.

THE CRITERION

DEFINITION: 'THE STANDARD BY WHICH OTHERS ARE JUDGED'

AFTER A SUCCESSION OF LANDLORDS FOR OVER 200 YEARS THIS HOSTELRY WAS NAMED THE CRITERION IN 1874.

The Criterion's history board.

THE CRITERION

HISTORY

THE PRESENT BUILDING DATES BACK TO 1874. THE PREMISES WERE OCCUPIED BY JOHN MILLER, BOOTMAKER, UNTIL THE MID-1880'S WHEN A LICENSE WAS ISSUED TO WILLIAM JOHN BAIRD FOR THE SUPPLY OF ALES AND PORTER ONLY. A FULL LICENSE WAS ISSUED IN 1889 TO JAMES MILNE. THE CRITERION BAR REMAINED IN PRIVATE HANDS UNTIL 1960 WHEN IT WAS TAKEN OVER BY MACKAY'S ST. LEONARDS BREWERY OF EDINBURGH, AND SUBSEQUENTLY BY WAVERLY TAVERNS LTD. THROUGH THE 1990'S THE BAR HAD A SHORT INCARNATION AS BERT'S BAR AND THEN LAFFERTY'S, BUT REVERTED TO THE CRITERION BAR IN APRIL 2006.

The Criterion's history board.

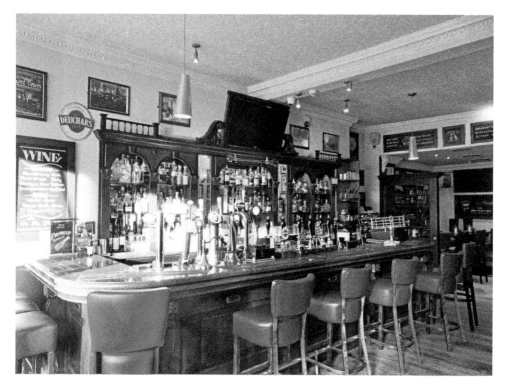

The bar area.

The Central, Market Street

The Central Bar can trace its origins back to 1887, when it was opened by David Mason under the name 'The Mason's Arms'. The Category C-listed Scot's Baronial-style building in which the pub is housed was constructed in the late 1860s, but it does not seem to have been operated as a pub prior to the establishment of the Mason's Arms. David Mason owned other hotel facilities within the town and by 1891 it was being offered for sale.

The pub passed through the ownership of several proprietors, with the most notable perhaps being David Leitch. Born in St Andrews, Leitch initially trained as a baker and moved to Leith where he took the post as a foreman at a bakery, before moving into the licenced premises trade. He returned to St Andrews in 1890 and purchased the Mason's Arms, most likely in 1891. He successfully ran the pub for a few years, extending it in 1893, before he moved to Musselburgh where he had purchased a pub named the Central Bar. Leitch did not, however, sell the Mason's Arms, and instead let the business to Mr A. McFarlane.

As well as successfully running his business interests, David Leitch was a prolific golfer. He was a member of the St Andrews Golf Club and had joined the Edinburgh Thistle Club while living in Leith. In 1888, while playing for St Andrews Club, he was entered into an open British Amateur Championship, which he won; in 1890, while playing for Edinburgh Thistle, he reached the semi-finals in the Amateur Championship

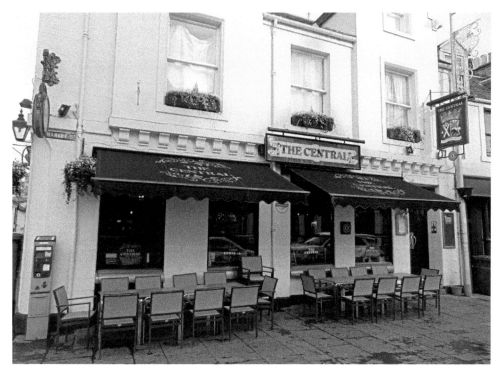

Above: The Central's bar.

Below: The Central's sign showing the St Andrews coat of arms.

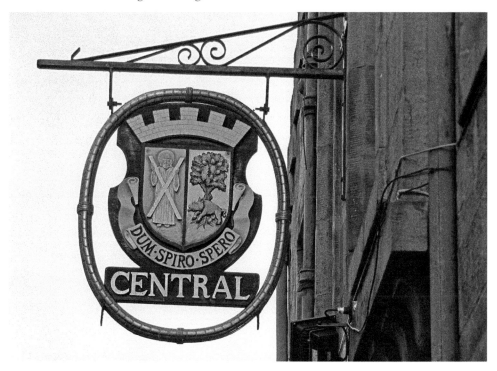

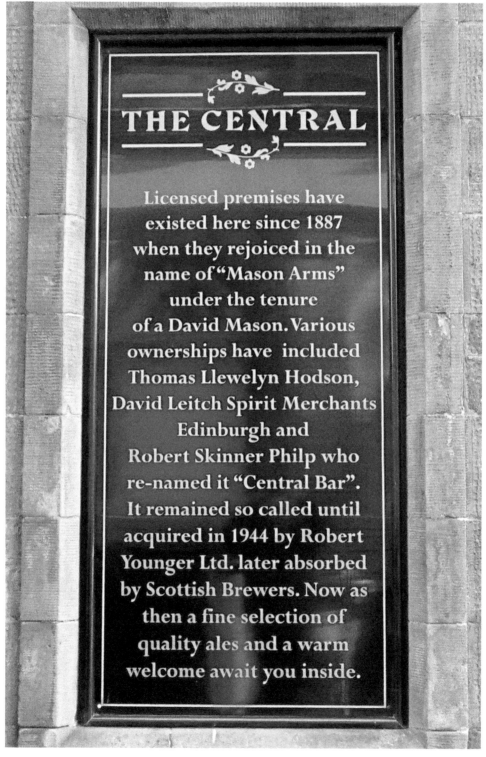

THE CENTRAL

Licensed premises have
existed here since 1887
when they rejoiced in the
name of "Mason Arms"
under the tenure
of a David Mason. Various
ownerships have included
Thomas Llewelyn Hodson,
David Leitch Spirit Merchants
Edinburgh and
Robert Skinner Philp who
re-named it "Central Bar".
It remained so called until
acquired in 1944 by Robert
Younger Ltd. later absorbed
by Scottish Brewers. Now as
then a fine selection of
quality ales and a warm
welcome await you inside.

The Central's history board.

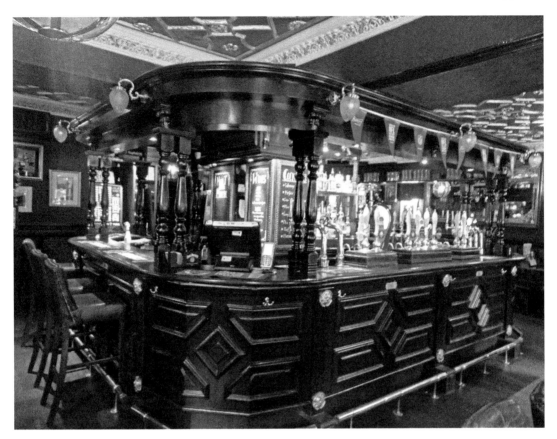

The Central's bar with ornate painted ceiling panels.

at Hoylake, and in 1893, he competed in the Scottish Foursomes Championship, which he won along with his partner, taking away the Times Trophy. He also ranked highly in the Telegraph and Post Cup.

When he returned to St Andrews in 1914, he once again took over the running of the Mason's Arms and continued to play competitively, serving a term as the club captain. He was particularly well known for retaining his golfing skills despite his age, and in 1932, aged seventy-four, he won the Haig Cup of the St Andrews Golf Club and continued to play daily until a short time before his death in 1935. He also continued to run the Central, only selling it to Mr Philip a few months before his passing.

There are varying versions of the reason the Mason's Arms changed its name to the Central Bar, the most popular of which is because the pub is central in Market Street (or at least central in the old market area of the street). Others tell that it is because of the large, central island bar inside the pub, a quite unusual feature in pubs today. However, the paper reports telling of the death of David Leitch state that he renamed the bar (contrary to the information board outside the building that states Mr Philip changed the name) after his return to St Andrews, and it was named after his pub in Musselburgh.

As with the exterior, the pub retains its traditional appearance and charm with many original features remaining. The large central bar houses a wide range of drinks, including a wide selection of real ales, both bottled and on tap, and the breweries own 1730 pale ale, named after the year the brewery was established.

The Keys Bar, Market Street

The Keys Bar is one of the oldest pubs in St Andrews, with the current building dating back to 1850, although an earlier hostelry may have stood here since 1590. The pub forms part of the former Stewarts Hotel, a purpose-built hotel in the heart of the town. In 1858, the hotel was renamed the Cross Keys Hotel and, although the hotel accommodation was sold off and converted into housing in 1981, the Keys Bar remains trading.

As mentioned in the introduction, the Keys was one of the favoured locations for the Society of St Andrews Golfers for eating, drinking and meeting prior to the construction of the Royal & Ancient Clubhouse. It is recorded that for their spring and

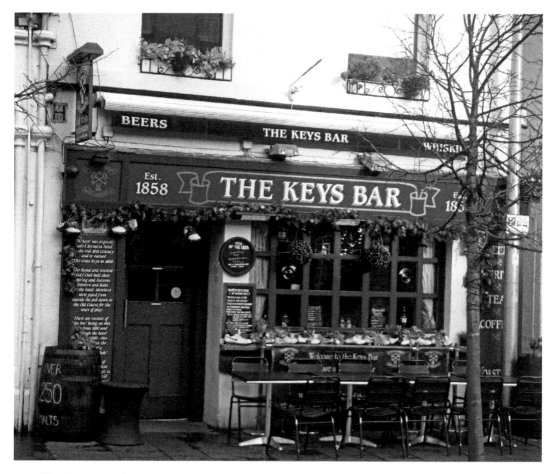

The Keys exterior.

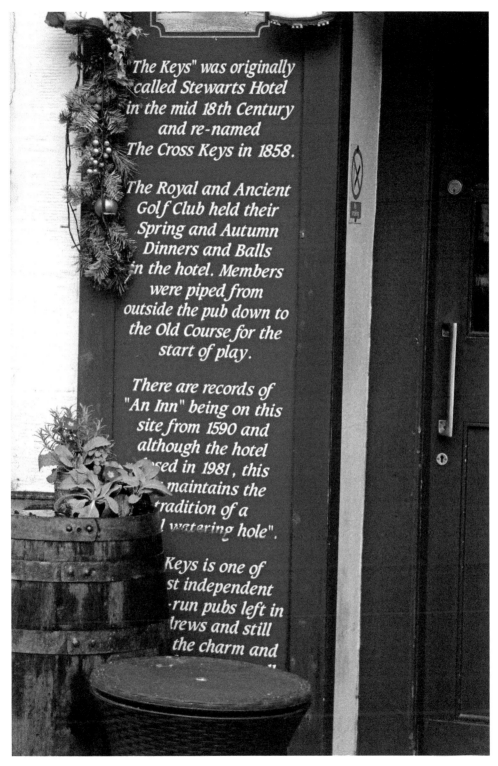

"The Keys" was originally called Stewarts Hotel in the mid 18th Century and re-named The Cross Keys in 1858.

The Royal and Ancient Golf Club held their Spring and Autumn Dinners and Balls in the hotel. Members were piped from outside the pub down to the Old Course for the start of play.

There are records of "An Inn" being on this site from 1590 and although the hotel ...sed in 1981, this ...maintains the ...tradition of a ...l watering hole".

...Keys is one of ...st independent ...run pubs left in ...trews and still ...the charm and

The Keys history board.

autumn dinners and balls, the members of the club were led by a piper from the pub to the Old Course to start their round of golf. It also became a popular venue for wedding receptions and was the location of a farewell dinner for Old Tom Morris in 1851 when he moved to Prestwick for a short while. The pub was also a bit of a trendsetter in St Andrews, with it advertising a new cocktail bar as early as 1950.

Today the pub retains much of its original charm and atmosphere and takes pride in remaining independent, allowing it to provide a traditional 'local' feel. While the Keys is popular with residents of the town, visitors enjoy the relaxed atmosphere and the wealth of information that the regulars can offer.

Despite its relatively small size, the Keys Bar offers possibly one of the widest ranges of drinks in the town, with an extensive choice of local beers and a range of spirits that includes over thirty types of gin and 270 malt whiskies. With such a large choice of whisky on offer, the staff are happy to offer a few samples so you can decide which you prefer, or a 'flight of whisky' is available, which provides six glasses of different whiskies as a package offer. The mix of a friendly welcome to all, good service and the selection of drinks seems to be a winning mix for the Keys Bar, as in 2014 they were declared the *Sunday Mail* Pub of the Year.

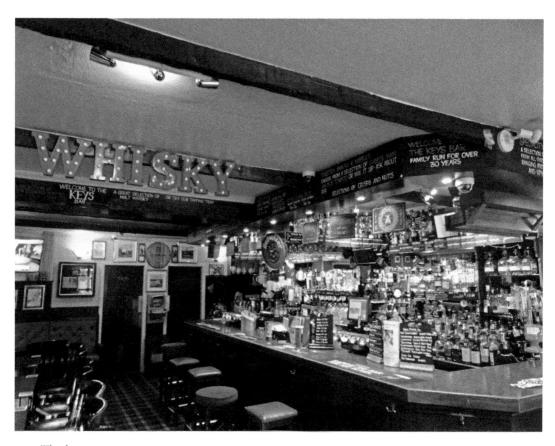

The bar area.

The whisky bar.

Forgan's, Market Street

Accessed through a private alleyway from Market Street, Forgan's is not the most visible nor most obvious pub in St Andrews. It was opened in 2013 and it was the restoration of the building in which it is housed that revealed some of the secrets of St Andrews past.

The property was a former golf club factory owned and operated by Forgan, the longest running golf club builder in the world. In 1819, the Society of St Andrews Golfers appointed a local carpenter, Hugh Phillip, as their golf club manufacturer. Using apple and pear wood for the heads of the clubs, and ash for the shaft, Phillip was considered a master in golf club design and manufacturer. Following his death in 1856, his nephew, Robert Forgan, took over the business, and Forgan's was born. The company grew rapidly, with imported hickory being used, which was dried for at least a year in large black sheds at the side of the fairway of the 17th hole of the Old Course. Robert Forgan's most notable apprentice was Jamie Anderson, a golfer who went on to win the Open Championship three times and after whom a street is named in the town. The factory was visited by Edward, the Prince of Wales, who had been appointed the

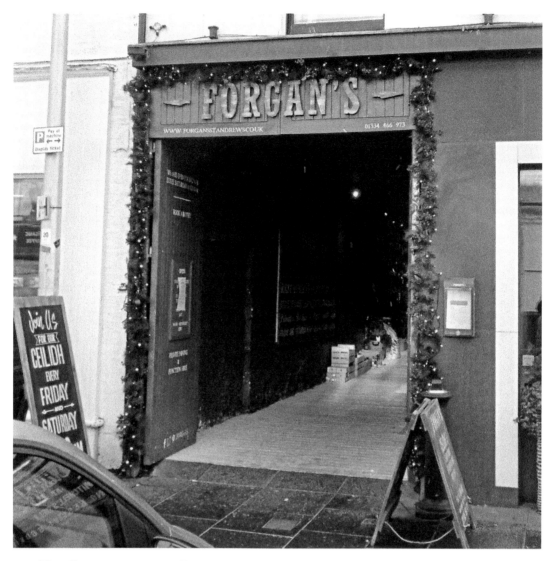

The alleyway entrance to Forgan's.

captain of the Royal & Ancient Golf Club in 1863 and had commissioned Forgan's to make a set of clubs for him. The prince was so pleased he awarded them with a royal warrant, which allowed them to stamp the prince's crest (three plumed feathers) on their clubs. In 1901, the prince became king, and he appointed Forgan's as the official club makers to the king, which allowed them to stamp a crown on their clubs instead of the prince's crest. From 1902 Forgan's proudly displayed an insignia above their door stating 'Golf club maker to his Majesty King Edward'.

The business had by then been passed to Thomas Forgan, one of Robert Forgan's sons, and under his leadership the company expanded to employ over forty staff, producing over 600 clubs a week that were sold worldwide. As the marketplace later

became flooded with mass-produced clubs from America, Forgan's struggled to survive and were eventually taken over by the American company 'Spalding' in 1945, who continued manufacturing clubs in St Andrews until the 1960s. The Forgan's golf club brand has since been revived and continues to trade.

The factory site on Market Street was later utilised by Murray Mitchell's, a well-known family butcher, and housed cold stores and office space used by the business. When the butcher closed due to retirement, the buildings were purchased by the Glasgow based G1 group, and it was probably while work was being carried out that the relevance of the building was once again rediscovered when the contractors discovered four original Forgan club heads, 3 feet below the floor level. The heads were found to be No. 1 Irons, or Cleeks, a type of club used for driving from the tee that is no longer in use. With the site's past uncovered and the discovery of the Cleeks, the decision was made to name the bar/restaurant 'Forgan's' in homage to its past, and the neighbouring deli, which fronts the building and is sited in the old butchers shop, was named 'Mitchell's' in honour of Murray Mitchell's.

At first glance, Forgan's appears to be a restaurant, and that is its primary function. Once the food service ends, the premises stay open until late as a pub and they are particularly well known for their late-night ceilidh held on a Saturday. With an extensive drinks menu (the online version extends to forty pages!), there is sure to be something to suit everyone, and 'sipping packages' are also on offer, which give a selection of beer or wine based on your personal tastes. Their own specially blended 'Forgan's Ale' is also on offer, which is brewed at the nearby Eden Brewery.

The Vic, St Mary's Place

The Victoria Café was originally opened in the early 1900s by Miss Jane F. Blair, who owned and operated the property for many years as a tearoom with an external upper-level garden in which customers could dine. Architectural records from 1922 state that Miss Blair based the building design on a similar establishment that she had seen in Germany.

A large part of the business was providing meeting facilities for various organisations based within the town, and it was within these premises in October 1927 that a meeting took place that would lead to the establishment of the St Andrews Rotary Club, part of a worldwide organisation that aims to provide activities for the local community. Those present at the meeting were golf club manufacturer Peter Forgan, ladies outfitter David Mackie, gents outfitter Andrew Peddie and burgh surveyor William Watson. Together, along with a local architect named Alfred Scott, the five formed the foundation for the Rotary Club. From these humble beginnings the club has grown considerably and, amongst other activities, they hold an annual international golf competition, in which Rotary Club members from all over the world come to St Andrews to compete on the Old Course.

The Victoria Café continued to operate as a tearoom for decades before opening in the evening as a pub. With two distinct areas, one housing the daytime café that stayed open as a pub later, and a second area that was solely a pub, it became a favourite with the students, partly due to its proximity to the Union Building and partly because it was

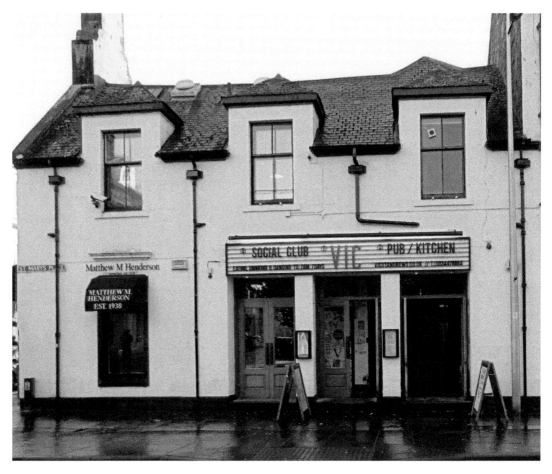

The exterior of the Vic.

not particularly expensive compared to other pubs in the town. The dated appearance of the property became more of a feature rather than something that put people off, and at the weekends both pub areas were often full to capacity with revellers.

In 2012, the pub underwent a major refurbishment and rebranding to reopen as 'The Vic'. The old-fashioned interior was replaced with a contemporary finishing. The two areas were retained, with the old tearoom becoming known as the 'Pub & Kitchen', and the former bar area becoming known as the 'Social Club'. The Pub & Kitchen serves food all day, with drinks served in jam jars and teacups, paying homage to the old Victoria Café. Video games and old-fashioned board games are also on offer to pass away the hours. Once food service ends, the drinks continue to be served, with music and DJs to create a vibrant atmosphere. The Social Club opens up as a relaxed place to meet, with facilities to play table tennis, video games on the big screen or just watch television with friends while enjoying a drink. At the end of the week and during the weekends, DJs move in at night time and the Social Club becomes a mini nightclub.

The Vic offers a wide and varied range of drinks, including cocktails, punch bowls and a selection of gins. The connection with the early use of the original Victoria Café to provide meeting facilities for organisations within the town has also been maintained, with The Vic actively supporting local societies through sponsorship and hosting events for them.

The Student Union, St Marys Place

Although not open to the general public, with so many students and university employees in and around the town, all of whom can use the Union and take friends and relatives in as guests, it would seem only fitting to include it in a book such as this.

The Union occupies a large, prime site in the centre of St Andrews, and the building incorporates other facilities such as a café, clothing store and the university's bookshop. It would be fair to say that the large, square 1970s-style building is not particularly in keeping with its surroundings. Its appearance has, however, been considerably improved recently with the addition of a new glass frontage that, although still modern in design, contrasts well with the traditional stone buildings that stand around it.

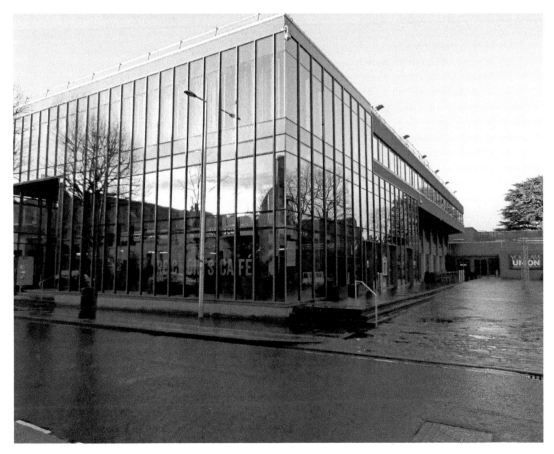

The exterior of the Student Union Building.

The Union building had previously been located in other parts of the town, including the corner of Butts Wynd and North Street, a building that was once home to James Crichton, known as 'The Admirable'. The Old Union Coffee Shop now occupies these premises.

At that time, there were separate Union facilities for men and women, but in 1963 they united and moved into the current building, which was opened, in its original form, in 1973. The Union is built on, or very close to, the site of Greyfriars Chapel, which was established by Bishop James Kennedy in 1458. Comprising of a church and a cloistered courtyard, this Franciscan friary took its name from the grey robes worn by the twenty-four friars who stayed there. As with many of the religious buildings in St Andrews, the reformation resulted in the destruction of the chapel and nothing now remains of the entire complex other than a well in a private garden on the nearby street, Greyfriars Garden.

The Union was officially opened by the actor and comedian John Cleese, as part of his role as the rector of St Andrews University, a position filled every three years based on a vote among the students. The aim of the Union building was to bring together

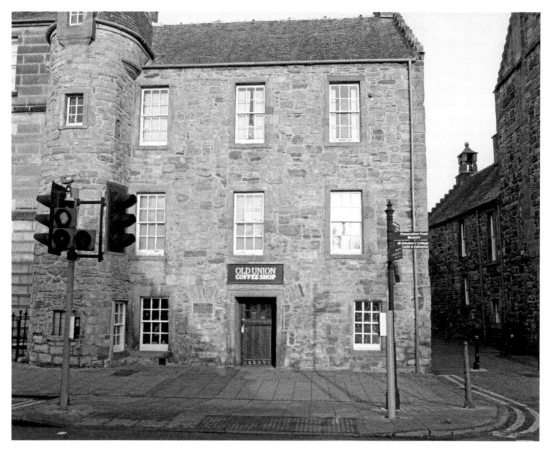

The Old Union, now operated as a coffee shop.

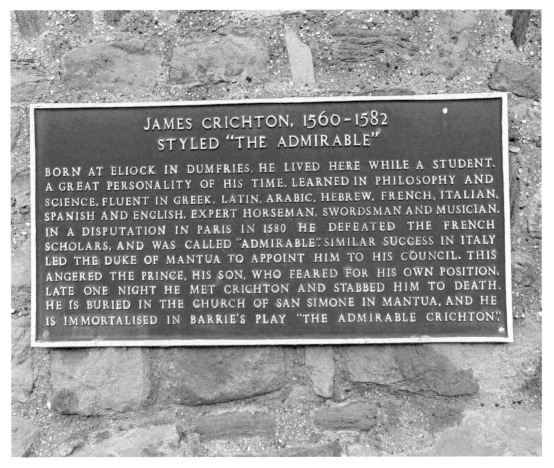

JAMES CRICHTON, 1560-1582
STYLED "THE ADMIRABLE"

BORN AT ELIOCK IN DUMFRIES, HE LIVED HERE WHILE A STUDENT.
A GREAT PERSONALITY OF HIS TIME, LEARNED IN PHILOSOPHY AND
SCIENCE, FLUENT IN GREEK, LATIN, ARABIC, HEBREW, FRENCH, ITALIAN,
SPANISH AND ENGLISH, EXPERT HORSEMAN, SWORDSMAN AND MUSICIAN.
IN A DISPUTATION IN PARIS IN 1580 HE DEFEATED THE FRENCH
SCHOLARS, AND WAS CALLED "ADMIRABLE". SIMILAR SUCCESS IN ITALY
LED THE DUKE OF MANTUA TO APPOINT HIM TO HIS COUNCIL. THIS
ANGERED THE PRINCE, HIS SON, WHO FEARED FOR HIS OWN POSITION.
LATE ONE NIGHT HE MET CRICHTON AND STABBED HIM TO DEATH.
HE IS BURIED IN THE CHURCH OF SAN SIMONE IN MANTUA, AND HE
IS IMMORTALISED IN BARRIE'S PLAY "THE ADMIRABLE CRICHTON".

The plaque commemorating James Crichton.

facilities for the students into one place. The building was extended in the early 2000s to provide a function hall and bar, and in 2013 work started on a major refurbishment of the building to create improved facilities for the modern student. The Union contains a number of bars, each with its own distinct character.

The Main Bar is, as the name suggests, the largest bar in the Union Building. During the day it is popular with students looking for a coffee and a place to meet or study, but at night it becomes a lively venue, with one of the latest licences in town. Serving a full range of drinks, including cocktails and special deals to ease the financial pressures, students are allowed to sign in up to two guests each, so there are opportunities for non-students to enjoy the facilities.

Situated on the top floor of the building, with large windows overlooking St Marys Place, you will find the Beacon Bar. Set up as a cocktail bar, with a sleek, modern finish, the Beacon is popular with students seeking a quieter night out.

The Union is also where you will find the only nightclub in the town. Named Club 601, the venue has a lively bar and regular DJs catering for different tastes in music.

Sandy's Bar was established to provide a more traditional pub feel. A wide range of local bottled beers and real ale on tap is available, which can be enjoyed while lounging on large, leather Chesterfield sofas and armchairs. The bar is named after Sandy MacKenzie, the late Union Bar manager who passed in 2015. Sandy was hugely popular with the students, with many saying he treated them like family, and was always known for wearing quirky ties as he worked. Prior to his passing, Sandy also had the honour of having a beer named after him. Specially brewed by the Eden Brewery, Sandy's Ale is offered on tap at the bar.

The Union is also proud to have achieved Best Bar None Gold awards. Best Bar None is a national award scheme promoting the responsible management of premises serving alcohol through the knowledge and skills of the staff to build positive relationships between the police, authorities and licensed premises to reduce alcohol-related crimes and the harmful effects of misuse of alcohol to create a safe environment for customers and staff.

In addition to John Cleese as rector, and Prince William and Catherine Middleton as students, the university has also seen a number of notable alumni studying there. These include the former leader of the Scottish National Party and First Minister Alex Salmond, the Conservative politician Michael Forsyth, the political editor for BBC Scotland, Brian Taylor, and Olympic cyclist Sir Chris Hoy, all of whom no doubt spent time within the pubs of the Union Building. Therefore, when visiting, you never know whom you might be rubbing shoulders with.

The Blue Stane, Alexandra Place

This basement bar has been a firm favourite in the town for many years. Although the pub may appear small from the entrance, it actually extends across the basements of several properties up to the corner of City Road, creating a deceptively large floor area.

A hostelry has stood here since the late 1800s, originally as the Alexandra Hotel and later as the Old Station Hotel and, while most of the premises have now been converted into housing, the bar remains. The pub has traded under several names, all with strong connections to traditions in St Andrews. It traded under the name 'Kates' after the legendary Kate Kennedy, a figure with strong connections to the university. Believed to have been named after Lady Katherine Kennedy, the niece of Bishop James Kennedy (c. 1408–65) and founder of the town's St Salvador's College, the Kate Kennedy Club was established in 1926 as an elite men's-only club at the university, admitting only a few students a year to join the ranks. An annual Kate Kennedy procession also takes place through the town every year, which consists of all the characters from the town and universities past and, of course, Kate herself, a role played by a man. The club has received a lot of criticism in more recent years, including from Kate Middleton, the Duchess of Cambridge, who, in 2002 during her time studying at St Andrews University, helped found the Lumsden Club, a women's-only club, in protest at the elitism of the Kate Kennedy Club. In 2009, after the appointment of the first female principal, the university withdrew its recognition of the club.

Although the club made the decision to allow female members in 2012, it is perhaps the controversy that surrounded them that prompted Kates to be rebranded as the

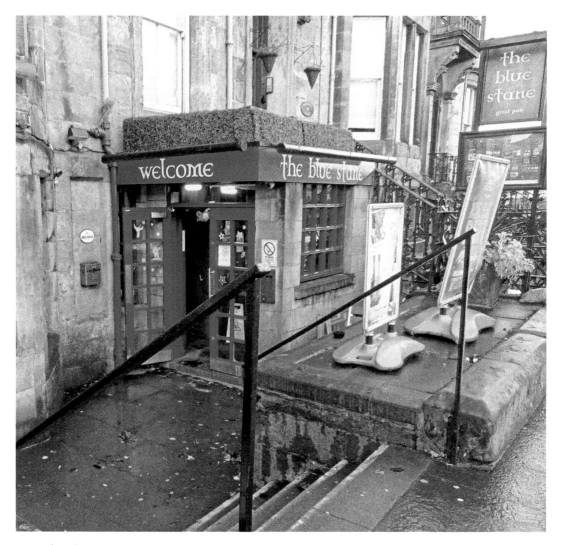

The Blue Stane.

'Featherie and Firkin'. The 'Firkin' part of the name comes from the Firkin Brewery, with the term 'Featherie' relating to an early golf ball made from a stitched leather pouch stuffed with chicken or goose feathers, which were both made and used by Old Tom Morris in the town. This golfing icon, both in St Andrews and throughout the golfing world, is best known for his incredible success as a golfer, but he was also an accomplished golf club and ball manufacturer, which he latterly produced from his workshop overlooking the 18th green of the Old Course, a hole now named after him on the course he helped to design. Following a restructure, the pub was passed to the Scream pub chain, which focused on pubs aimed at students. The pub was renamed 'The Raisin', a name that is again taken from a tradition of the university, albeit a fully inclusive one, to re-establish the student connection. The Raisin Weekend dates back

over 600 years, and is part of a mentoring custom whereby older students take new students under their wing to ease them into university life. The weekend ends on Raisin Monday, where students would meet in the courtyard of St Salvator's College dressed in silly clothing, selected for them by their mentors, to help the new students meet others, and this has now grown to become possibly the largest foam party in the country.

The current name for the pub is taken from a very important but largely forgotten historical artefact that sits in the small garden grounds of the building. The large glacial rock was said in folklore to have been thrown from Drumcarro, an area just a few miles outside St Andrews by a giant who was intent on killing St Rule, the monk who traditionally brought the relics of St Andrew to Scotland's shores. The rock fell short of its target and lay at Magus Muir, an area of woodland close to the town that is now more associated with the infamous assassination of Archbishop James Sharp in 1679, and it was later moved several times until it arrived in its current position during the Victorian era. The stone is believed to have been used as the coronation stone for King Kenneth MacAlpine, the first king of the Picts and the Gaels, around the year 843, and is considered to be a good-luck talisman. It became a centrepiece for meetings of the

THE BLUE STANE

The Blue Stane is a relic of Pre-Christian Pictish St. Andrews when it had some now forgotten ritual significance. It is reputed to have been the coronation stone of Kenneth MacAlpine, who united the Kingdoms of the Scots and the Picts in 843A.D. According to legend, a giant standing either at Drumcarrow or at Blebo Craigs threw the Stane at St. Rule's cell on the Kirkhill, but it fell short.

The Blue Stane is shown on the John Geddy map of St. Andrews of about 1580, at which time it stood on the south side of what is now Double Dykes Road. It later stood at the City Road crossroads and was moved here in Victorian times. It may have also once stood by the West Port. Men would give it a placatory pat and women a cautious curtsey. The St. Andrews pikeman touched it as a talisman before departing for the Battle of Bannockburn in 1314. The fairies were supposed to frequent the Stane and it was a favourite trysting place for lovers. In later years it was the rendezvous of the Carters' Society on the day they held their annual races.

Geologically, the Stane is made of Dolerite (or Whinstone), an iron - and magnesium-rich igneous rock which is found on Drumcarrow Craig. This Stane was probably plucked by glaciers which covered Fife during the last ice age and was then dropped nearby as a glacial erratic when the ice retreated about 14000 years ago. The giant story looks like folk history to explain the movement of the stane by a glacier to its present site.

Another Blue Stane outside Crail Kirk has a similar explanation except that it is said that the Devil threw it from the May Island (Also made of whinstone) when the Kirk was being built, with one part just missing the Kirk, and the other part falling near Fife Ness. Inverness also has a Blue Stane, the Clach-Na-Cuddain, the rocking stone, a greeting in former times.

Plaque telling the story of the Blue Stane.

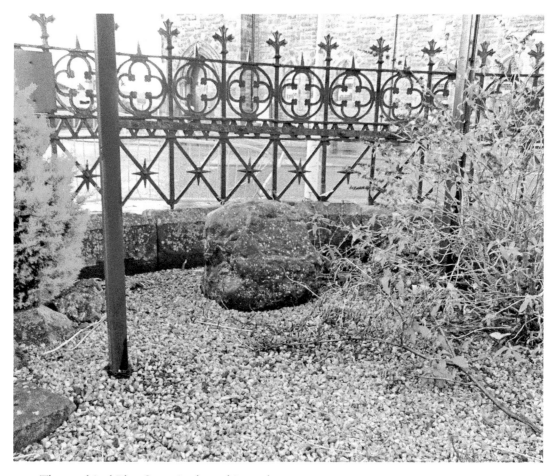

The mythical Blue Stane in the pub's garden.

authorities, including oath taking and swearing allegiance to the kings of Scotland, and it is also connected to the fabled Faerie kingdoms.

Today, the pub offers a warm welcome to all, and with several large-screen televisions, it is popular for watching sporting events and it also offers live music and DJs. Large leather sofas are situated throughout the pub, giving drinkers a bit of a more comfortable place to sit and enjoy the wide range of beers, ciders and around fifty blends of whiskies on offer.

No. 1 Golf Place, The Golf Inn, Golf Place

With the Old Course and the Royal & Ancient Golf Club within sight of the pub at the Golf Inn, this is easily one of the most enviable locations in St Andrews. A hotel has operated from here since 1827 and over the years it became a popular haunt for both golfers and caddies.

In 1870, the Golf Inn was the chosen location for a celebration to mark one of the most significant points in the history of both the game of golf and the Open

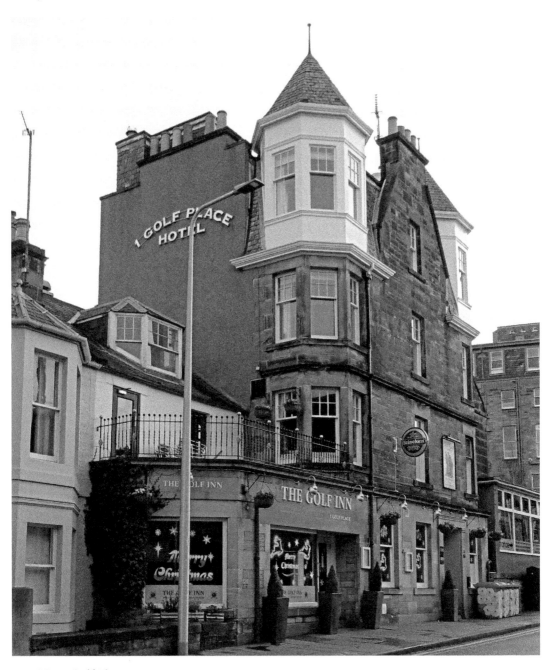

No.1 Golf Place.

Championship. St Andrews at the time was home to two formidable players, a father and son team, both named Tom Morris (known as Old Tom and Young Tom to differentiate between them). Old Tom Morris was born in St Andrews in 1821 and was involved in golf from a young age, eventually taking up an apprenticeship with Allan

Robinson, a club and ball maker and generally considered the world's first professional golfer. They often teamed up to enter pairs competitions and became known as 'the Invincibles'. In 1851, Old Tom was offered a post at the newly established course at Prestwick on the west coast of Scotland, which, despite Young Tom Morris having just been born earlier that year, he accepted. While at Prestwick, he was responsible for the design and maintenance of the course, as well as manufacturing and selling equipment and providing coaching. In 1865, the Royal & Ancient were keen to have Old Tom back in St Andrews working on the Old Course, and the offer of a salary of £50 was too good for him to turn down, so he returned to the town with his family. Young Tom by then was already demonstrating that he had inherited his father's gift in playing golf and was establishing himself as a player. Old Tom set about redesigning the Old Course, yet all the time he had been working he had never stopped playing competitively, and won the Open Championship in 1861, 1862, 1864 and 1867.

Young Tom entered his first Open Championship in 1865 when he was just fourteen years old, but he failed to complete the competition. He entered again in 1866 when he finished in ninth place, and in 1867 when he finished fourth. In 1868, Young Tom became the youngest player ever to win the Open, a record that still stands, and, notably, Old Tom finished second in the same year. Young Tom went on to win the Championship again in 1869 and 1870, which caused a problem for the organisers of the Open. The 'trophy' at that time was a championship belt, and the rules stated that if a player won three consecutive Open Championships, they were entitled to retain ownership of the belt. There is little doubt that the intention behind the rule was to give incentive, but with no real expectation that anyone would achieve such success, yet at the age of just nineteen, Young Tom Morris had done so. The championship that year had been held at Prestwick (on the course designed by Old Tom) and when Young Tom returned to St Andrews, he was met by his friends and supporters at the train station, and taken to the Golf Inn where a celebratory reception was held in his honour. It is considered that almost everyone involved in golf at that time was present in the Golf Inn that night, where both Old and Young Tom paid tribute to each other. The result of Young Tom winning the ownership of the championship belt was a new trophy having to be made, and the Claret Jug that is still played for today was purchased as the replacement. Ironically, Young Tom went on to win the Open Championship in 1872 (there was no championship in 1871) and so became the first winner of the Claret Jug, and quite possibly another night of celebration at the Golf Inn was enjoyed.

The bar at the inn has operated under several names including McSorleys, but it was as the Niblick that it became a firm favourite with locals and students, with the bar staff getting to know many of the regulars by name despite it being a particularly busy pub. The name 'The Niblick' came from an old hickory club, with an iron head similar to a modern sand iron, which was known as the Niblick Iron. During the 2015 Open Championship, the bar was taken over and refurbished by the global sports company Nike and was famously rebranded 'No.1 Nike Place' for the duration of the competition.

With a relaxed, light and modern feel, the pub is well stocked with a vast range of whiskies and other spirits, with beers being available both on tap and in bottles.

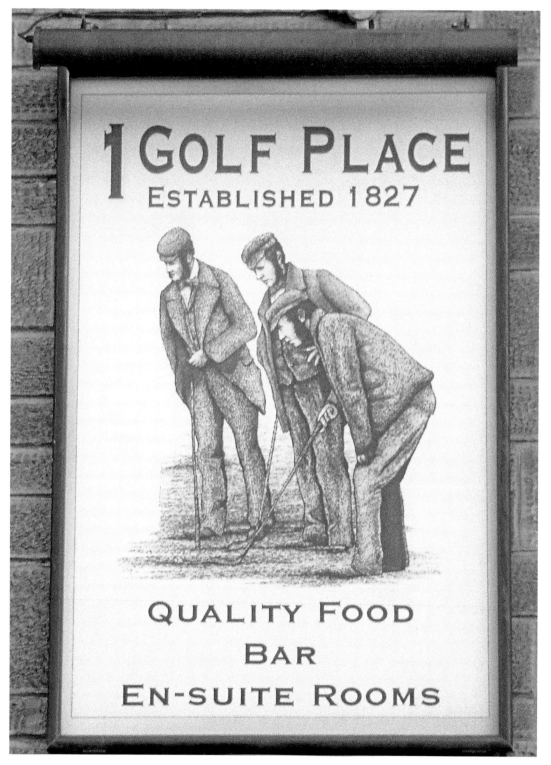

The bar sign.

Dunvegan Golfers Corner, Pilmour Place, North Street

The Golfers Corner Bar and the Dunvegan Hotel is widely considered to be the most famous '19th hole' in St Andrews. The building itself dates back to the 1820s, but it was not until 1993, when Jack and Sheena Willoughby, who regularly visited St Andrews to play golf, purchased the hotel and bar that it began to gain its fame. The couple devoted much time and effort into refurbishing the building and growing the business, and their hard work paid off, as it has now been deemed to have an almost magnetic attraction for the golfers when visiting the town, as well other sports professionals, film stars and politicians.

It is difficult to pinpoint what it is about the Dunvegan that draws in the rich and famous. While there is no doubt the property provides excellent facilities, it does only have a 3-star rating and is surrounded by 5-star hotels, each with their own bar offering equivalent levels of luxury. It is thought that the attraction to the Dunvegan

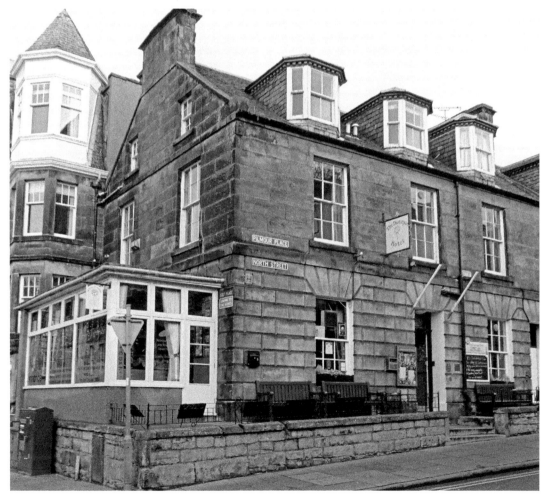

The Dunvegan Hotel.

started during the 1994 Dunhill Championship, when the American golfers Tom Kite, Fred Couples and Curtis Strange visited the bar, and became return customers throughout the duration of their stay in St Andrews. Upon their return to America, the golfers are believed to have talked about their time at the Dunvegan and when the Open Championship arrived in St Andrews the following year, there were a number of golfers all keen to visit the bar they had heard so much about.

Since then the popularity of the Dunvegan has gone from strength to strength, and the list of big names who have visited is possibly one of the most impressive in the world! To name a few from the golfing world: Arnold Palmer, Tiger Woods, Ernie Els, Rory McIlroy, Lorena Ochoa and Stacy Lewis have all visited, and from the world of film, Clint Eastwood, Sean Connery and Kevin Costner are among the many guests. Former US President George H. W. Bush and astronaut and the first man on the moon Neil Armstrong have also enjoyed the comforts of the Dunvegan. But it is not only the stars who frequent the bar; it is also popular with locals, caddies, visitors and students.

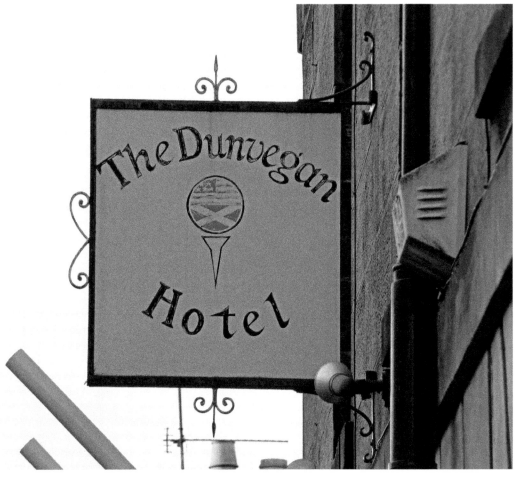

The sign showing it is only a stroke from the Old Course.

The Golfers Corner Bar.

One thing that is unique about the Dunvegan and Golfers Corner is the décor. The walls are covered in historical prints of every winner of the Open Championship held at St Andrews since 1873 and photographs of almost all of the famous visitors. There are so many pictures that they do not just cover the walls, they cover the ceiling as well, with some saying that no-one knows what colour the walls are in the Golfers Corner as there are so many pictures.

Facilities within the bar area include large-screen televisions on which all of the golf tournaments are shown, although when showing a competition from St Andrews, the pub is so close to the Old Course that on occasion the roar of the crowd is heard before a clinching shot is shown on the television due to the delay in transmission, which can give away the result. Behind the bar there is a selection of beers, wines, ales and over fifty single-malt whiskies. A welcoming atmosphere is always guaranteed and you really do never know whom you might end up enjoying a pint with when visiting.

Playfairs Bar, Pilmour Place

Pilmour Place is a terrace of seven grand town houses at the end of North Street, built in the early 1820s. The Pilmour Hotel occupied No. 1 Pilmour Place and was operated as a hotel with a pub for many years, with it perhaps being best known among older drinkers as The Holmlea, a former name that the pub operated under. The Homelea offered an easy-going atmosphere, with an emphasis on providing a relaxed drink, with a number of board games and traditional pub pastimes, such as darts and dominos, being available. Behind the bar a range of traditional drinks were on offer, and it was a popular pub with students and lecturers, who would play games against each other, as well as the locals.

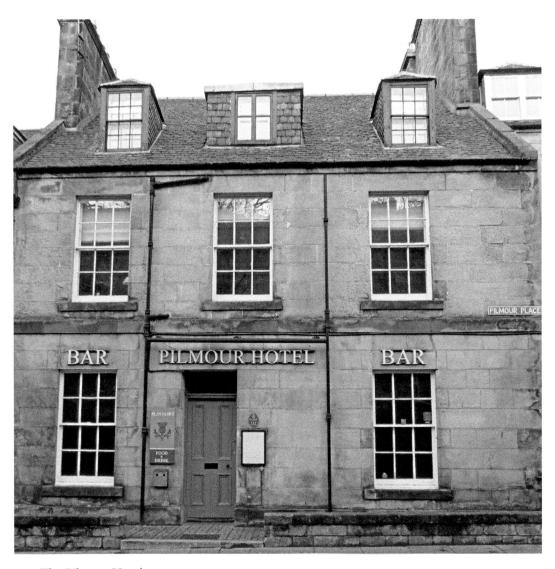

The Pilmour Hotel.

The hotel and bar were recently purchased by the adjoining Ardgowan Hotel, on Playfair Terrace, a neighbouring row of terraced properties built on North Street in the mid-nineteenth century, designed by the architect George Rae, who was responsible for a number of the fine buildings in the town. Playfair Terrace is named after the Playfair family, who played a significant role in the history of St Andrews. Revd James Playfair (1738–1819) was the principal of St Andrews University in addition to his role as a minister. He was also the official photographer of the then Prince of Wales. His son, Sir Hugh Lyon Playfair (1787–1861), was a soldier and politician and he also followed in his father's footsteps as a photographer. After retiring from the army in 1834, Sir Playfair returned to St Andrews where he was appointed as provost in 1844, a position that he filled until his death. Sir Playfair is credited with building the public library in St Andrews and being pivotal in bringing the railway line to the town. He was also responsible for the creation of the Royal & Ancient Golf Club, and is often credited with having revived the town of St Andrews.

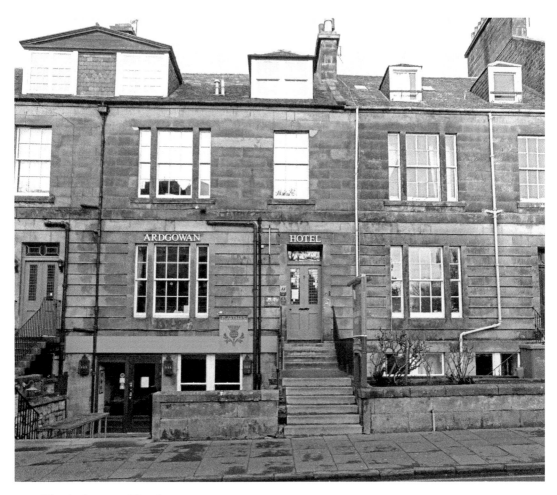

The Ardgowan Hotel.

JOZEF STANISLAW KOSACKI (KOZACKI)
1909 - 1990

After the fall of Poland in 1939 a substantial fragment of the Polish Army was reconstructed and fought in the Battle of France. After the defeat of France in 1940 the survivors came to Britain where they were regrouped, re-equipped, and stationed along the eastern coast of Scotland building a long chain of coastal defences against a feared German invasion.

First Lieutenant Jozef Kozacki was a signals officer of the First Polish Army, stationed in St Andrews. In 1937 he had been commissioned by the Department of Artillery of the Polish Ministry of National Defence to develop an electrical machine capable of detecting unexploded 'duds' on firing ranges and battlefields. He successfully developed a machine constructed at the AVA Electronics factory in Warsaw - the same factory which built the first secret Polish replicas of the German military 'Enigma' cipher machine. Escaping to France after the fall of Poland, Kozacki altered the purpose of the machine to detect land mines. After evacuation to Scotland and to St Andrews, the Polish Military Command revived the work.

The army headquarters was in Eden Court on The Scores and in the Ardgowan Hotel in Playfair Terrace, and it was there that Kozacki was given a laboratory, workshop, and an aide with whom to complete and perfect the mine detector. Prototypes were built, and tested on the West Sands. In the North African desert theatre of war the British Army was hampered by the lack of an effective mine detector. The Polish Government in Exile submitted Kozacki's design. In trials it triumphed and was immediately accepted. 500 examples of Mine Detector number 2 (Polish) were rushed to North Africa in time for the battle of El Alamein, where it proved its worth. The basic design was still in use during the 1991 Gulf War, and the Mark 4 version until 1995. Kozacki's design weighed 30 lbs, was portable, reliable, effective and relatively easy to maintain in the field.

Kozacki's invention has saved countless thousands of lives and limbs world-wide and continues to do so. He received neither payment nor recognition, save for a treasured letter from King George VI. How did the mine detector work? It consisted of two coils; the first connected to an oscillator, which generated an oscillating current of acoustic frequency. The second coil was connected to an amplifier and telephone. When the coils came into the presence of a metal object, the balance between the coils was disturbed and the telephone connected to headphones reported an altered signal.

Kozacki returned to Poland after the war, where he became one of the pioneers of electronic and nuclear machinery. He held the Chair of Electronics for Nuclear Research in Swierk, and also became Professor at the Military Academy in Warsaw. He died in 1990, having lived to see the collapse of Soviet domination of Central Europe, and was buried with full military honours.

Erected by The St Andrews Preservation Trust, Gordon Christie Bequest

The memorial plaque for the achievements of Józef Kosacki.

The premises played an important role during the Second World War. After the fall of Poland and France, a large proportion of the surviving Polish Army came to the UK where, after regrouping, they were stationed in strategic positions along the east coast of Scotland. One of those soldiers was First Lieutenant Józef Kosacki, a signals officer who, before the start of the war, had been commissioned to develop a machine capable of detecting unexploded ammunition on the firing range. While in the UK, Kosacki was based in St Andrews, where the Polish Army had been given two buildings to act as their headquarters, one being the Ardgowan Hotel. Kosacki had already started to adapt his machine to detect landmines, and he was given an area in the Ardgowan to act as a temporary laboratory to allow him to complete his work. Early prototypes of his mine detector were successfully tested on the West Sands at St Andrews, and 500 were shipped to the British Army forces in North Africa, where they faced a substantial danger from landmines. The Polish mine detector, as it became known, was such a success that the basic design was still in use right up to the First Gulf War (1990–91). After the war, Kosacki returned to Poland where he continued to work in the electronic and nuclear industries, holding a number of senior positions until his death in 1990. His role, and that of the Ardgowan Hotel building, are recognised by a plaque attached to the railings outside.

The Ardgowan Hotel occupies two of the former houses at the end of Playfair Terrace and, since 2003, has been owned and operated by the same family. Although connected, Playfairs Bar is now solely within the former Pilmour Hotel and offers a street terrace to the front and large decking area to the rear for outside drinking. The front terrace is popular with visiting golfers, who can stop for a pint on their way back to their hotels from the Old Course and sit outside with their clubs while watching the world go by around them. The selection of drinks offered has also been increased since the early days as the Holmlea, with a wide selection of whisky being available and the pub promoting their knowledgeable staff who can help guide those not sure of which whisky best suits their palette. Traditional beers are offered on tap, with specialist and craft beers also available. The pub also provides an ever-growing range of gins, to cater for increased popularity of the drink. A number of large-screen televisions ensure that even when the golfers stop in for a meal and a few drinks, they can keep up to date with any competitions being played. At the time of writing, both the Ardgowan Hotel premises and Playfairs Bar close for part of the winter season.

Greyfriars Hotel, North Street

The property in North Street occupied by Greyfriars Hotel dates back over a century, and was originally run as a tearoom named the Tudor Café, the name coming from the mock-Tudor styling of the building. As well as being a popular place to dine, the café became a favoured meeting place for local organisations including the Step Rock Amateur Swimming Club and the Rotary Club. It was also used to provide dance school facilities, and housed the club rooms for the St Andrews Bridge Club.

Being situated closer to the golf courses than other cafes in the town, it was also used by golfers. One who went on to work there was Ken Greig, a successful amateur player. Greig won the Scottish Amateur Golf Championship in 1930, and went on to

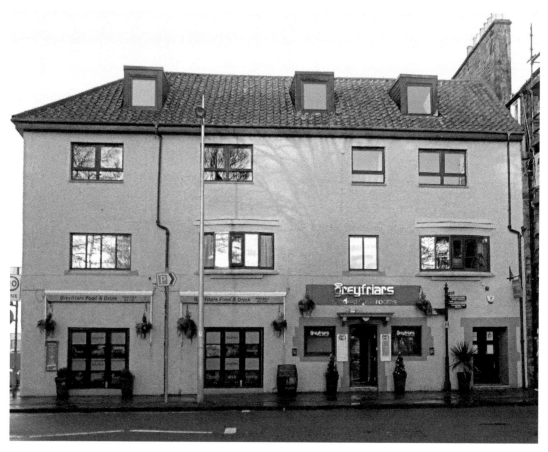

Greyfriars Hotel & Bar.

be selected to play for Scotland in the international matches against the other nations of the UK, only to be dropped in what became a quite sensational story at the time. Undeterred, Greig went on to compete successfully in numerous other championships. A report published in the *Dundee Courier* newspaper on 19 September 1938 perhaps gives an insight into how resolute Greig was. The story tells that having injured his leg while playing golf on the Old Course, he continued to work at the Tudor Café for a period of three weeks before seeking medical advice, where an x-ray revealed he had broken his thigh bone! The report ends stating that he was now in the St Andrews Cottage Hospital.

The Tudor Café was also a popular venue with wedding parties, and Ken Greig again appears in the records in 1938, when he was best man at his brother's wedding, with the reception being held at the Tudor.

The Tudor Café later became the Tudor Inn, with the ground floor providing bar facilities and the upper floor guest accommodation. I have fond memories myself of visiting the Tudor in my younger years, and the somewhat strange nautical interior design, given that there is no real connection between the inn and the sea. There was

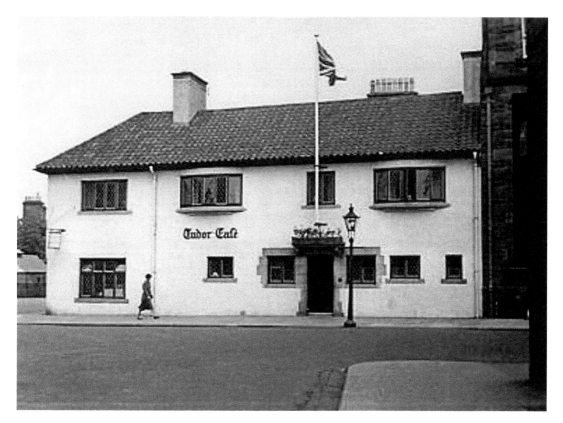

The Tudor Café. Note the height of the lower storey.

always a great atmosphere in the pub, and the tired appearance never seemed to put people off. In 2005, the pub was sold and major renovation work was undertaken, including adding an extra storey and attic accommodation. The bar area was opened up to create a light, contemporary space better suited to the modern drinker. As is common with many hotel-based pubs in the town, during the day it is more focused on providing meals and a relatively quiet place to enjoy an afternoon pint. At night time, Greyfriars is a favourite location for all in the town, with a wide range of drinks on offer including bottled, world and craft beers, a choice of cask ales including those brewed locally at the Eden Brewery, and a variety of both bottles and draught lagers. A range of thirty malt whiskies, eight types of gin, nine vodkas and up to fourteen rums are also on offer. The pub also boasts having four large plasma screens, with BT Sports and three Sky boxes, meaning it is particularly popular during sporting events as they can show multiple events and even something else for the non-sports fans.

The name comes from the Greyfriars Friary, which was established nearby in 1458 but was completely destroyed a century later during the Scottish Religious Reformation. Nothing remains of the buildings today, the stones having all been used to construct the surrounding properties.

The bar area.

Rascals Bar, North Street

Rascals Bar sits neatly beside the New Picture House, the only cinema in St Andrews, and was originally the café for the cinema, which was built in 1931.

The pub traded for many years as a bar/restaurant named the Four Woods, before going through a number of successive rebrands in a relatively short period of time. From the Four Woods, which had more of a traditional tearoom feel than a pub, it became Broons Bar, a pub that was very popular with the students, before becoming Howies Bar & Restaurant, part of the Howies restaurant chain known for its informal dining that also attracted the students. Its next guise was as McKays Student Bar, a pub that served food and, as the name implies, was aimed at the student market. McKays was noted for being a good place for a quiet drink and bite to eat during the day, while very busy with revellers at night. The pub was later rebranded as the Pitcher House Restaurant & Bar (no doubt a play on words with it being next door to the Picture House) and specialised in American food. Although originally focusing on the restaurant side of the business, the pub side of the business was later reintroduced, with regular 'open-mic' nights being held.

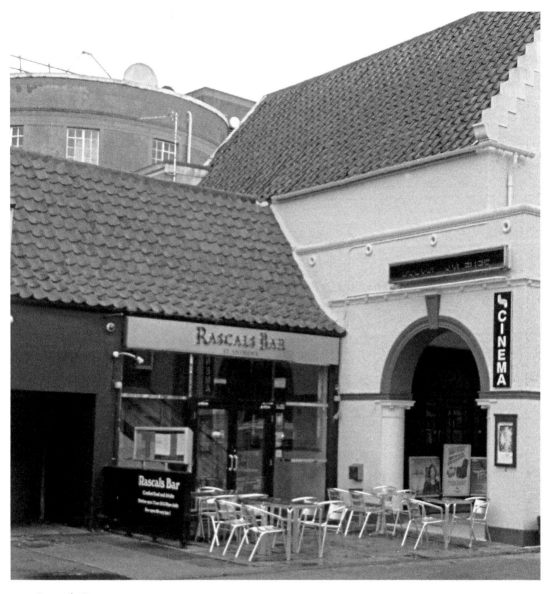

Rascals Bar.

Rascals Bar opened in 2011, and while still recognising the importance of the student market, the new owners also sought to cater more for the locals and visitors than their predecessors had, by providing a children's menu and catering for families.

This approach, combined with many years of experience of managing pubs in St Andrews, worked with Rascals today attracting a wide and varied range of regulars. The pub is contemporary in style, offering modern yet comfortable surroundings, and have enough Sky TVs to be able to show multiple football matches, along with pub favourites such as a pool table.

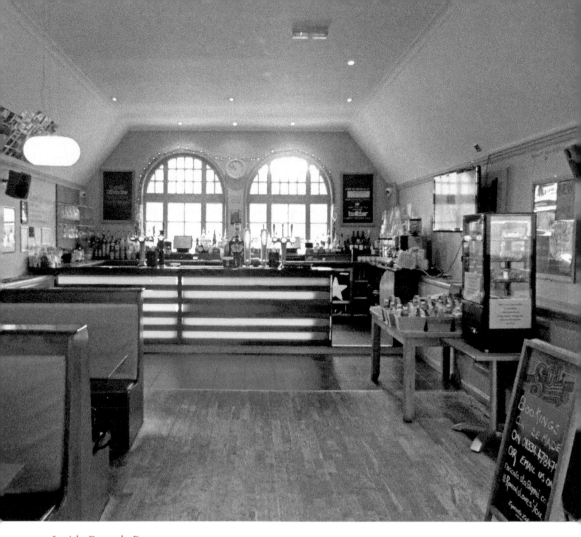

Inside Rascals Bar.

The Beer Kitchen, North Street

Having only opened their doors in November 2016, the Beer Kitchen is the newest pub in St Andrews.

The building in which it is situated is the former Salvation Army Meeting Hall, which in 2006 was converted into an Italian-themed restaurant named the Glass House. This name was chosen mostly due to the amount of glazing added to the property, especially to a side extension, and because it was one of four restaurants in the town, each with the word 'house' incorporated into the name. The use of the glazing to the frontage of the property, which includes access to a small rooftop patio area, gave diners views over the street to the tower of the historical St Salvator's Chapel. The Glass House traded until 2015, when the owners surprised many residents by announcing it would be closing its doors as of 22 December that year.

The building stood empty until the craft brewer Innis & Gunn announced they would be opening the premises as the Beer Kitchen, the third pub in their chain with

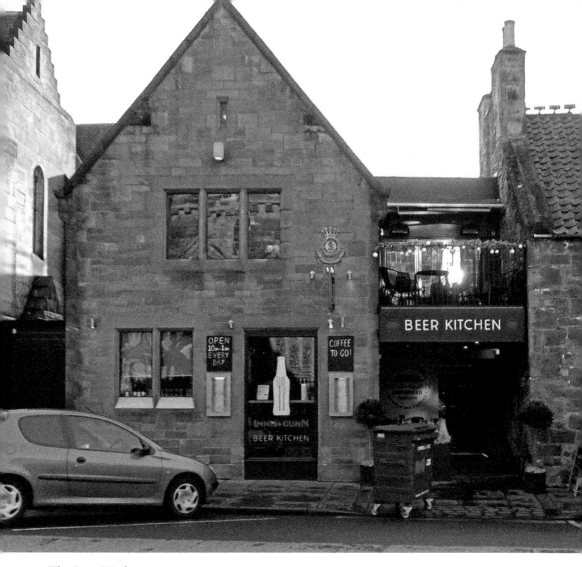

The Beer Kitchen.

the same name. The funding for the pub was a reflection on how new the company is, as it was raised through crowd funding, a means that allowed people to make varying levels of investment and in return received a share of the company representative of the amount invested.

The Beer Kitchen opened its doors in November 2016 and aims to bring something new to the pubs in the town. The history of the brewer is quite unusual. They were approached by a large whisky company in 2002 with an enquiry about seasoning their oak casks with the sweet and malty character found in a full-flavoured beer. Innis & Gunn set about creating a special blend of beer, which was added to the barrels for a month to allow it to infuse the wood, before it was disposed of and the whisky added, giving the whisky a unique quality. Sometime later, they were approached again and advised that some of the workers had sampled the beer after

Above: Bar Manager Iain Douglas behind the bar.

Below: The view from the first floor.

it had been in the casks and found that it too had developed a very specific flavour. Since then, the brewery continued to develop and refine their oak-aged beers, taking pride in the flavours. The modern, light pub attracts beer lovers from all backgrounds and offers an extensive range from all over the world, including their own brews, and up to twelve beers on tap.

A selection of wines, ciders and cocktails are also on offer, along with 'boilermakers', which are described as essentially being American 'hauf an' a hauf', or beer and bourbon. This is said to have originally been drunk by steelworkers in the nineteenth century, made up from a shot of whiskey in the beer. To meet the tastes of the modern fashions, the boilermakers are offered based on different spirits, including gin and rum as well as whisky.

2

The Scores and The Links

Although the game of golf can trace its roots in St Andrews back to the fifteenth century, it was not until the eighteenth century that the prevalence of the game in the town really took off. As the popularity of the game grew, so too did the demand for facilities in the town. Despite this, the areas around the Old Course, comprising of the streets named The Links and The Scores, divided by Golf Place, remained substantially undeveloped. With the construction of the Royal & Ancient Clubhouse on Golf Place, overlooking the first tee of the Old Course, which commenced in 1853, other developers started to move into the area.

The first significant hotel development in this prime location was the Rusack's Marine Hotel, which was constructed in 1887 on The Links, overlooking the fairways of the 1st and 18th holes on the Old Course. The hotel was enlarged in 1892, indicating the level of demand in such a short time. The next major development was the Hamilton Hotel, which was constructed between 1894 and 1895 on The Scores, overlooking the Royal & Ancient Golf Club, and the 1st tee and 18th green of the Old Course. The Golf Hotel also opened around this time, on the corner of Golf Place and The Links. Although this hotel also had commanding views over the Old Course, it was not on the same scale as the other two developments mentioned.

In 1893, land reclamation work also started as the sea was perilously close to both the Royal & Ancient and the edge of the Old Course. George Bruce, a town councillor and builder, opted to use a method that involved setting out the outer edge of the area they wished to reclaim with old fishing boats, which were filled with rocks to keep them in place against the tide. With the sea held back, the area between the boats and the land was then infilled, extending the land out to the line of boats. Although this area of land has since been secured using more modern methods, it is still known as the Bruce Embankment after George Bruce and, having been a putting green for many years, it is now used as car parking for the British Golf Museum and the surrounding attractions.

With the Old Course and the Royal & Ancient secure from coastal erosion, the hotel developments in the area continued throughout the nineteenth and twentieth century. A number of fine houses were also constructed at the same time, infilling the spaces

between the hotels. Finally realising The Links and The Scores were highly desired locations for visiting golfers, several of the houses were later changed to hotels, and some of the golf clubs also moved in to set up clubhouses. In order to capitalise on the extra visitors being brought to the town, many of the hotels established their own restaurants and bars to provide exclusive facilities for their patrons, removing the need for them to go into the town centre to use the establishments there.

The properties in the area remain some of the most sought after in the town and to golf fans worldwide, resulting in some of the hotels being converted back to apartments, while many of the pubs remain. Most are within the ground floor or basement levels of the hotels where they were originally positioned. With the golf course attracting thousands of visitors every month, including non-golfers, and many more during the major competitions (it is estimated that the Open Championship brings in around 200,000 visitors to the town), the pubs around the Old Course are now mostly all open to the public and are favoured by the golfers and caddies, as well as attracting the locals. The pubs in this area have also been attracting the students, especially after one became a regular haunt for a certain student prince during his time studying at the university.

The Russell Hotel, The Scores

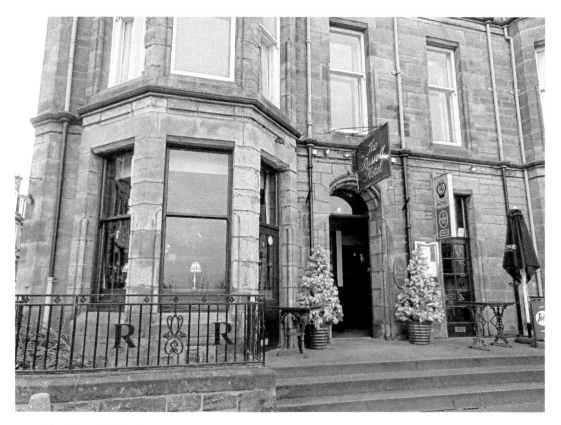

The Russell Hotel.

Situated in a Victorian town house that was built in 1896, the Russell Hotel is just a few minutes' walk from both the Old Course and the town centre. The hotel was originally named the Westcliff Hotel, due to its position being close to the cliff edge, overlooking St Andrews Bay.

For those looking for a meal and fine wine rather than a traditional pub setting, the Russell Hotel offers a unique experience in their private dining area. The walls of the room are lined with wooden golf lockers, each one bearing the name of the winner of the Open Golf Championship from every occasion it has been played at the Old Course in St Andrews, since Tom Kidd in 1873. Aptly named The Locker Room, this is considered one of the most desirable private dining rooms in the town.

The bar at the Russell must be one of, if not the smallest pub in the town, but it truly lives up to the old saying that size does not matter. An external terrace is available to sit and enjoy your drink during the day and on summer evenings, but when the weather is not particularly agreeable, an open fire welcomes visitors inside in the traditional lounge bar. A range of wines is available, along with beers, ales and spirits, including speciality gins and a choice of fifty Scottish malt whiskies. This little pub is popular with visitors, golfers, university staff and locals and offers a more relaxed atmosphere than some of the other town bars.

Ma Bells, Hotel Du Vin, The Scores

The basement bar, Ma Bells, is possibly one of the most famous in the town. The building was once a grand house, and was later converted to the Golf Hotel. Ma Bells, which sits below the hotel, was always a favourite haunt for locals, students and golfers looking for a livelier night out, and was very much a traditional pub. More recently, the hotel was taken over by the Hotel Du Vin chain, and while they have changed the name of the hotel, the name Ma Bells, and its strong association with nightlife in St Andrews, remained. The pub has, however, undergone a full refurbishment, and now has a much more contemporary style, with leather armchairs replacing the old, hard stools.

The pub came to the attention of the media when one particular St Andrews University student started to be seen drinking there on nights out. That student was none other than Prince William, and he is reported to have enjoyed a few pints of cider in the bar, under the watchful eye of his security team, and later in his time at the university he is said to have been a regular with his now wife, Kate Middleton. The pub seems to have had quite an impression on the student prince, so much so it was reported that in a speech he delivered at a fundraising event in New York, for St Andrews University Scholarships, he joked that it is sometimes said that the undergraduates leave St Andrews University in one of two states, either married or alcoholics, before going on to address the audience and suggest that any parents of undergraduates at St Andrews should simply ask their son or daughter if they know what Ma Bells is, and if they reply that they do, it would be a good idea to remove the glass of wine in front of them! This of course is not a true reflection of the reality, although it is correct that an estimated one in ten of the university students meet their

Above: The Hotel Du Vin.

Below: The basement entrance to Ma Bells.

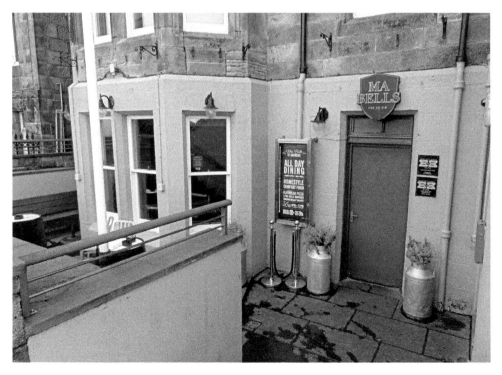

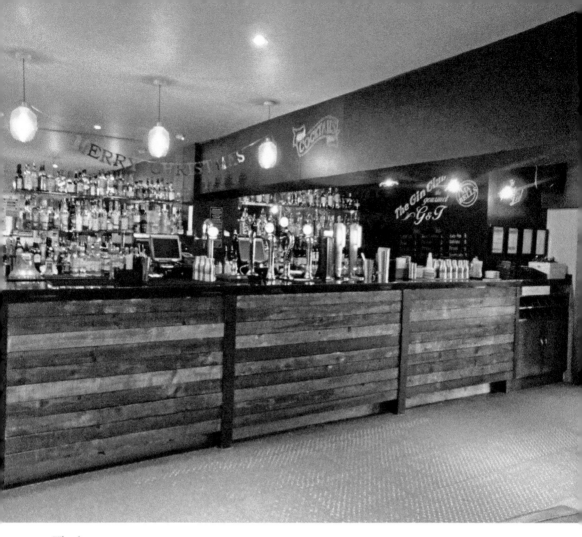

The bar area.

future spouse there, including Prince William, yet it is probably more an indication of how much the prince enjoyed his nights out in Ma Bells.

Prince William is not the only famous person to be connected to the pub. It attracts golfers and celebrities from all walks of life while visiting the town. In 2006 it was reported that Hollywood movie star Bill Murray was turning fiction into reality during a visit there. The article stated that he was in town for the Dunhill Golf Championship, which attracts a lot of golfing celebrities for the Pro-Am competition, when he visited Ma Bells with some fellow golfers. While enjoying a drink, he was approached by a twenty-two-year-old blonde student, who chatted with him for a while before inviting him to her house party to meet her friends, an offer that he accepted. The paper noted the similarities between this situation and the storyline of the film *Lost in Translation*, in which Murray plays the role of a middle-aged movie star who, while abroad, meets up with a younger, blonde postgraduate student in a hotel bar, who invites him back to meet her friends.

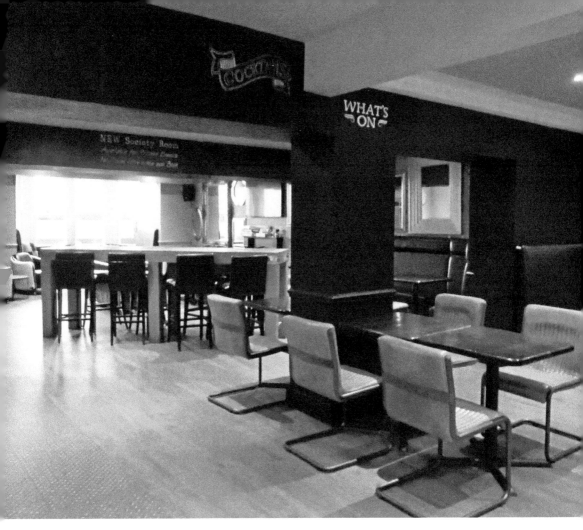

The seating area.

Ma Bells now offers regular live music, as well as DJ nights, and behind the bar there is an extensive selection of lagers, beers and real ales, as well as spirits and a choice of cocktails. There has been some speculation regarding the origin of the name of the pub. Some believe it means 'My Bells', and relates to the bells from the cathedral, which were removed during the reformation and taken away by ship, only for the ship to sink in St Andrews Bay, which the Hotel Du Vin overlooks. The name however relates back to when the pub was originally used as a tearoom, which was ran by a lady named Mrs Bell. Locals at the time saw Mrs Bell as a motherly figure, and she became known as Mother Bell, abbreviated to Ma Bell. The tearoom in turn became known as Ma Bell's Tearoom, and the name stuck.

Chariots Bar, The Scores

Chariots Bar is situated in the basement of the Scores Hotel, a building that is steeped in local history.

Chariots bar below the Scores Hotel.

In 1918, a Scottish-born doctor named Sir James MacKenzie arrived in St Andrews. The general practitioner and cardiologist had been working in London for over twenty-five years, where he established a successful consultancy and was widely recognised for his research work in conditions of the heart. In 1902, he had published a paper named 'The Study of the Pulse' in which he described an instrument he had named the Polygraph, and in 1908 he published 'Diseases of the Heart', based on his own diagnostic work. In 1915, he was knighted in honour of his work. However, he never forgot his roots as a GP, and the day-to-day problems they faced.

His reason for moving to St Andrews was considered by most to be for retirement (he was sixty-five years old at the time, and was a keen golfer); however, when he arrived in the town, he was appointed as the consulting physician to the Cottage Hospital, where he was able to meet and discuss issues with the local GPs. The following year, he established an Institute for Clinical Research, the first general practice research centre in the country. With the support of local businesses and the principal of St Andrews University, a Victorian town house dating back to the 1880s that had previously been used as the St Salvator's School on The Scores was leased, and then bought, to house

the research centre. It later transpired that St Andrews had been chosen in part because of the opportunity to work with the university. Sir MacKenzie headed the institute for several years and was actively involved in the research work until 1924 when, with his health deteriorating, he chose to return to London, where he died the following year. The establishment of the James MacKenzie Clinical Institute is widely acknowledged as the pivotal point in recognising the role of the GP as a speciality in its own right, with an important research role to play. The institute closed in 1944, and two years later, in 1946, the *Dundee Courier* newspaper ran a story stating that, while the building was being converted into the Scores Hotel, one of St Andrews' long-lost secrets may have been discovered.

The report surrounded the tales of a secret underground system beneath St Andrews, and one of the town's best-known ghost stories, the Smothered Piper. The theory of a network of tunnels is a sound one for the town – given its historical religious importance and the need for the archbishop and other senior members of the church to escape in the event of an attack. There are in fact several reports of entrances to possible underground chambers being found when the cathedral grounds were being prepared to be opened to the public, but they are said to have been hastily filled in to avoid delaying the work. The tale of the Smothered Piper is one that is common to several towns and cities in Scotland. A cave mouth used to lie in the cliff face in front of The Scores, and though few dared venture in due to a feeling of foreboding, many wondered where the cave went. One New Year's Eve, a young piper named Jock (predictably!) boldly declared that he would enter the cave and play his pipes as he went, allowing his route to be followed above ground. Against the wishes of his wife, Jock started his long walk into the darkness, with a crowd eagerly following the sound of his pipes towards the town centre, until they suddenly fell quiet. Jock was never seen again, and no one was brave enough to venture in to find what had happened to him. The cliff face collapsed a long time ago due to coastal erosion, and the entrance to the cave has been lost, but the spirit of Jock is still said to be seen, walking along the old cliff edge still playing his pipes.

The reporter stated that workmen had uncovered an entrance into a tunnel in the basement cellar at the front of the building. The passageway was said to have travelled north towards the sea and to where the entrance to Jock's Cave once was, and was partly constructed in stonework and partly cut into the rock. Unfortunately, the tunnel had collapsed a short distance in, though workmen believed that the tunnel would also continue on the other side of the building, with the basement effectively having cut through it when the building was constructed. Although a submission was made to the council for permission to open up the tunnel, nothing more seems to have been done, and this part of St Andrews lore was once again lost.

The bar itself is named after the 1981 film *Chariots of Fire*, which tells the story of the Scottish runner Eric Liddell and English runner Harold Abrahams, and their battle to overcome the odds to win gold at the 1924 Olympic Games in Paris, in the 400 metre and 100 metre races respectively. The opening scene of the film shows the athletes running along the West Sands in St Andrews, which lie in view of The Scores, before they are seen crossing over the 1st tee of the Old Course, with the Hamilton Grand

ERIC H. LIDDELL 1924 OLYMPIC GAMES

A portrait of Eric Liddell outside the pub.

The West Sands from the pub, where *Chariots of Fire* was filmed.

signed as the Carlton Hotel, and The Scores Hotel visible behind it. The connection between the film and the pubs of St Andrews does not solely lie with *Chariots* however, as it was reported that several of the extras in the film had only been approached by the producers the night before in the local bars.

With a location so close to the Old Course, The Royal & Ancient Clubhouse and the West Sands, Chariots Bar is popular with golfers, tourists and the locals alike. Internally, the pub retains a more traditional feel, with the walls lined with pictures of famous Scots. A stained-glass window showing a piper is situated in the entranceway, possibly depicting young Jock.

Hams Hame, Golf Place

Having opened in 2013, Hams Hame is another newcomer to the pub scene in St Andrews, yet it is situated in one of the most instantly recognisable buildings. Marketing itself as 'the newest 19th hole', Hams Hame is literally just across the road from the 18th green of the Old Course, and the closest bar to both the start and finishing point of the course.

The bar is situated in the basement of the Hamilton Grand, an iconic red-sandstone building, which has become a St Andrews landmark. Originally built in 1895 by Thomas

Painting showing the enviable position of the Hamilton Grand.

Hamilton. Reputedly after he was refused membership to the Royal & Ancient Golf Club, he vowed to create a building to overshadow the Royal & Ancient, the Hamilton Grand originally opened as the Grand Hotel. Seeking to meet the increasing demands of the ever-growing tourist market in St Andrews, the Grand Hotel offered new levels in luxury, and was the first building in Scotland to offer compressed gas-operated lifts and to also provide hot and cold running water to all bathrooms.

The hotel traded successfully for decades, serving the more affluent visitors to the town until 1942, when it was requisitioned by the Royal Air Force to provide accommodation and training facilities for its personnel. In 1946, the hotel was released back to the owners, yet despite extensive refurbishment, it never again recaptured its status or success, and in 1949 it was sold to St Andrews University as a student residence. Renamed the Hamilton Halls, the university offered accommodation in the building until 2005 when, through lack of investment and increasing expectations of facilities, the university deemed it to have no longer met the needs of the modern student and sold the building to an American investment company. Plans were submitted and work started to convert the property to luxury accommodation, complete with a

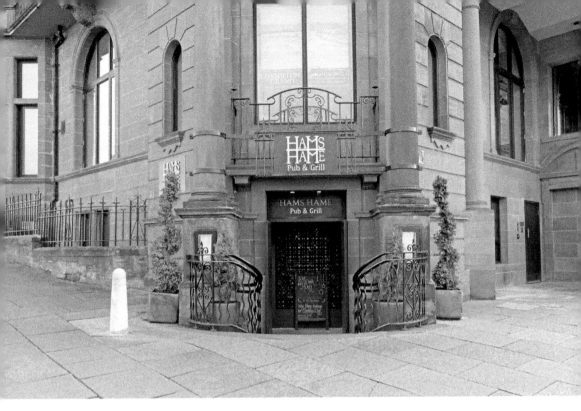

Entrance to Hams Hame.

helipad, aimed at the richest people in the world; however, the global economic crises put an end to the development, and the partially exposed building was abandoned and quickly started to fall into a state of disrepair. With the townsfolk and golfing world alike concerned that the building may be lost if action was not taken, the Kohler Co., owners of the Old Course Golf & Country Club, stepped in to take on the building. The proposal to convert it to luxury apartments remained under the new name, The Hamilton Grand, and the inclusion of facilities for visitors and the people of the town was also incorporated in the form of Hams Hame.

The pub has been designed to retain the original character and feel of the historic building, with solid-wood floors and beamed ceilings. There are options to sit in the booths that surround the outside of the bar area, or for larger groups there are large wooden tables with oak chairs, and there is a wide range of drinks on offer, including more than twenty single-malt whiskies and a dozen blends, and a selection of local- and Scottish-brewed ales, including the bar's own H&H ale. The name of the pub relates back to the original owner, Thomas Hamilton, with Ham being a shortened version of the surname and Hame being a Scots word meaning 'for home', and so the name essentially means Hamilton's home.

MacDonald Rusacks Hotel, Pilmour, The Links
Commonly known simply as the Rusack's, this hotel is one of the most prominent in St Andrews due to its location on the edge of the Old Course. Originally opening in

The front of the Rusacks Hotel.

The side and rear of the Rusacks Hotel overlooking the Old Course.

1887, the hotel was named the Rusacks Marine Hotel after its owner, Johann Wilhelm Rusack, who also owned a number of other hotels in the town. The building itself bears the date 1892, although according to the listed building records available through Historic Environment Scotland, this is the date when the building was extended and probably fully opened.

Other than a period of time during the Second World War, when the building was used as barracks for the armed forces, it has traded continuously and became a firm favourite for visiting golfers, including the professionals, dignitaries, movie stars and politicians, as well as those simply seeking a luxurious place to stay in St Andrews. One guest who attracted a lot of attention during his stay was Bing Crosby, the world-famous American singer and actor. In May 1950, Crosby was due to play in the British Amateur Golf Championship, and much speculation surrounded when he would arrive in the town, until he was spotted getting out of a taxi at the Rusacks Hotel. It seems that his entry was more for fun rather than any real intention to try to win as, playing against J. K. Wilson, a local golfer from St Andrews, Crosby was reported as frequently turning his attention to entertaining the crowd rather than the game in hand. After they completed their round, which Wilson won, Crosby continued to delight his gathered audience before being ushered back to the hotel. While the 4-star hotel is deemed to be

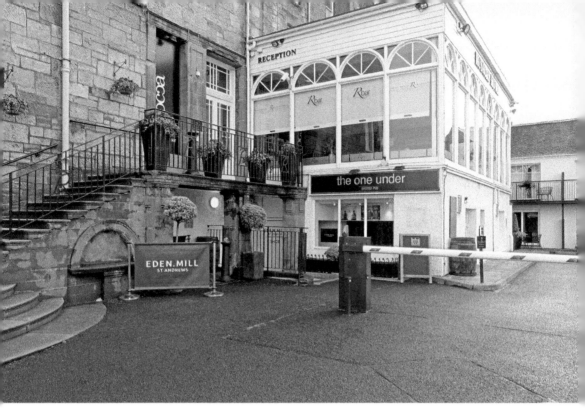

Above: Entrance to The One Under.

Below: The bar at The One Under.

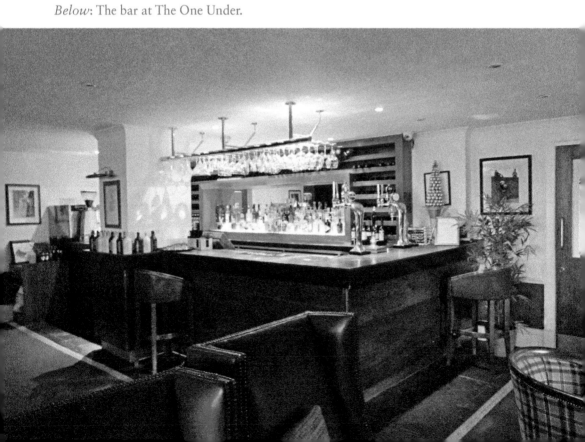

aimed at guests seeking a level of luxury – it even has a large 'Rolex' clock on the outside, leading to some saying that the hotel is so posh it even wears a Rolex – it does cater for all.

There are two bars within the hotel, both of which are open to the public. The One Under, located under the hotel as the name suggests, claims to be the first gastropub in St Andrews, generally considered a food-orientated pub. With a Michelin starred head chef overseeing the food in the hotel, the 'gastro' side of the business can be considered covered. On the 'pub' side, a wide selection of bottled and draught beers is offered, along with real ales and a choice of fine wines. The One Under is particularly popular with golfers stopping in for a drink and a bite to eat after a game of golf, and the pub even provides locker facilities to allow golfers to keep their clubs safe while enjoying the facilities.

The R Bar

The bar at the R Bar.

The second bar is not necessarily what most people will envisage when thinking of a pub, but it does offer alcoholic beverages and so does fall into the 'public house' category, so I have included it for completeness. The R Bar Champaign & Grain is a champagne and whisky bar based within the hotel itself, in a bright and spacious area, with views over the Old Course. With luxurious finishing, the R Bar offers a range of whiskies, along with a range of champagne and wines that can be bought either by the glass or by the bottle. A large choice of cocktails are also offered, along with a selection of beers. The R Bar, which also offers light snacks and meals, is popular with those seeking a relaxed drink in luxurious surroundings.

3

Further Afield

St Andrews did not start to grow significantly until the start of the twentieth century. Although the population had grown to around 9,000, the River Eden had always been a bit of an obstacle. The new bridges that had been constructed during the nineteenth century, along with the increasingly limited land available in the old town, resulted in the town starting to develop beyond the river, although this was slow at first, the population being in the region of 11,000 by the start of the 1950s. The post-war developments, common with many towns throughout the country, was only just starting to have an impact by that time, and over the following decades the population began to grow rapidly with the construction of street after street of social housing, followed by a boom in private housing.

New primary schools formed communities around them, yet what is particularly notable is that although new pubs did set up to cater for the increasing population, they predominantly remained within the town centre. Only one new purpose-built pub was constructed in the expanding town, which was situated in a small development of shops just off Tom Morris Drive to the south of the town centre, built in the 1970s. Named The Stables Bar, the pub traded successfully for around forty years, before closing recently. The pub is now a coffee shop with a children's play area.

The population of St Andrews today is around 17,000, with a student population of around 8,000, which is widely spread out with newer student residences lying outside the town centre. It is therefore not quite clear why other pubs have not tried to open away from the town centre, which is a conservation area meaning any alterations to the buildings are subject to an additional approval process. Perhaps it is just that the character and atmosphere in these ancient buildings continue to attract people to travel in from the outlying areas.

That is not to say all of the pubs in St Andrews are within the town centre, The Links and The Scores. A few pubs already existed outside, which found themselves with an increased customer base, and other new pubs did open, but within existing businesses where there was already an existing clientele, all much closer to the town centre or within the golfing area, rather than out in the residential developments.

Although all of the pubs in this section are outside the main areas of the town, they are all within a very short walk.

The Café Bar, The Byre Theatre, Abbey Street

Despite it being a relatively new pub to the town, the café bar has quickly become popular. It is based within the Byre Theatre, a modern building with a long history in the town. The original Byre Theatre was established in 1933 by local playwright and journalist Alexander Paterson. As the name suggests, the theatre was housed within a cow byre, which Paterson had leased from the council in a semi-derelict condition. With financial aid from the Hope Park Church, the Byre was transformed, although it is doubtful that actors today would put up with the facilities – the changing rooms for example were accessed via a ladder that had been taken from a decommissioned naval ship. The theatre, however, proved popular, with shows regularly selling out.

As with other theatres throughout the country, the Byre struggled to survive following the outbreak of the Second World War in 1939. With so many men sent off to fight, and Paterson himself leaving to join the Royal Air Force, it was difficult to find actors and skilled workers for behind the scenes, and a large enough audience. The role the theatre played in offering some distraction and lifting spirits during these bleak years was considered too important for the theatre to close, and the St Andrews Repertory Co. was established to make sure regular shows were still put on. Alexander Paterson returned after the war and resumed in the position of theatre manager.

The popularity of the theatre continued to grow, and by the 1960s it was apparent that the demand had outgrown the facilities. Due to a road-widening project in 1969, the original Byre was scheduled for demolition, and the opportunity was seized to build a new, much larger theatre a short distance away. The New Byre Theatre opened in 1970, with Alexander Paterson still in charge. The new theatre only brought more demand and, by the mid-1980s, it was again struggling for capacity and had become dated. Paterson sought to modernise the theatre, but instead the decision was made to

Model of the original Byre Theatre.

demolish it again and to construct a new, modern building. Sadly, Alexander Paterson died in 1989 and never saw the third generation of his theatre, which did not open until 2001. The global economic crisis of 2007/8 took its toll on the Byre due to changes in funding, and it went into liquidation in 2013, but it was saved the following year through a management agreement between St Andrews University, Fife Council and Creative Scotland.

The Café Bar is popular with students during the day due to the large, open space it offers, and because it is located within the theatre building, it attracts theatre-goers for pre-show food and drinks followed by aftershow drinks, which are also popular with students. Regular weekly events such as their Jazz Night, held once the food service has finished, attract revellers to the pub where they can enjoy a wide range of beers, ales, spirits and cocktails. The pub can be accessed from Abbey Road, but for a more scenic route, walk down via South Street and wander past some of the oldest buildings in the town.

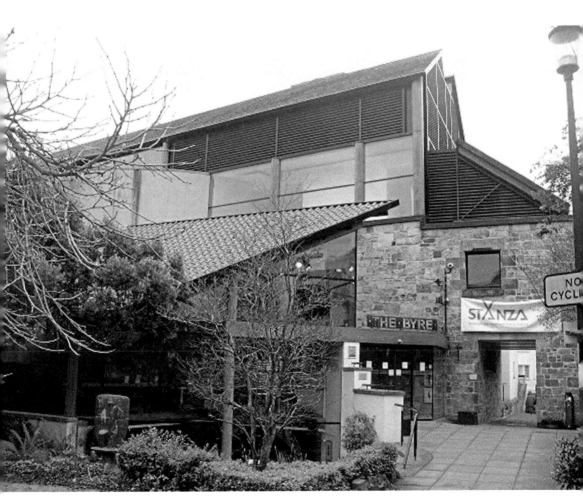

The main entrance to the Byre Theatre & Bar.

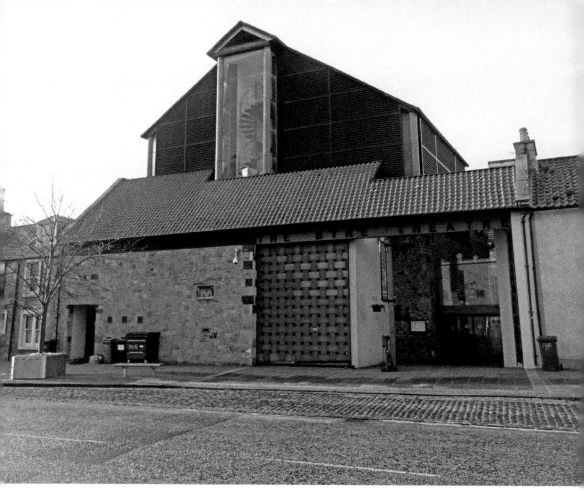

The rear entrance to the Byre.

The New Inn, St Mary Street

The New Inn, which sits a short distance outside of the centre of St Andrews on one of the main approach roads into the town, has traded here for many years, with maps as early as 1893 showing the pub. It is also possible that a far earlier building was situated here, or nearby, to provide rest and refreshment to pilgrims and later travellers, due to its position between an early tollbooth on the western approach to the town and the gateway into the historic centre. The pub is named after a building that once stood at the nearby Pends Gateway.

The *Hospitum Novum,* The New Inns, was the last building to be constructed within the grounds of St Andrews Priory, and marked a significant connection between the town and some of the best-known and influential members of royalty in the history of the country. In 1537, James V of Scotland and Madeleine of Valois, the daughter of Francis I of France, were married and several months of celebrations followed in France. Madeleine had suffered from poor health throughout her life and the festivities had taken their toll on her, prompting concerns to be raised about the effects that the Scottish climate may have on her, along with dirt and grime that came from city life

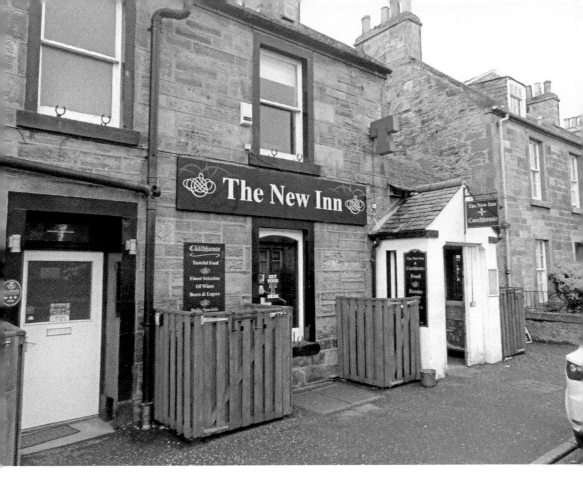

The exterior of The New Inn.

in Edinburgh at the time. Keen to provide his new bride with a place to recover after their long trip back to Scotland, King James instructed that a residence in St Andrews be built, which would offer fresh sea air and the security of being within the priory walls. The building that became known as the New Inns was hastily constructed, yet Madeleine was never to take up occupancy of her new home. When their ship arrived in Leith on 19 May, her health had deteriorated considerably and she was taken to the nearby Palace of Holyroodhouse in Edinburgh, where she died on 7 July, 1537. The grieving period for the king was short, and arrangements were soon in place for him to marry again to another French woman, Mary of Guise. It seems he was still keen to make use of the New Inns, and having had it refurbished for his new queen, who arrived in Scotland in June 1538, it was used for a celebration to mark their wedding. The building continued to provide accommodation for visiting members of the royal family, including Mary Queen of Scots, who was the daughter of James V and Mary of Guise, and was later used as a residence for the archbishops and their guests. After the religious reformation and the destruction of the cathedral, the need for the New Inns declined and the building fell into a state of ruin, before it was eventually completely demolished at the start of the nineteenth century. All that remains is the

The bar area of The New Inn.

former entrance to the grounds, which bears panels showing the royal arms and the arms of Prior John Hepburn of St Andrews.

It is unfortunate that this significant part of the history of St Andrews and its royal connections has been largely forgotten, but at least the name of the building lives on in the New Inn. With the pub being just a short walk from the centre, it is busy with both locals and visitors, partly thanks to it having rooms to let and its proximity to the beaches of the East Sands. It is also popular with students from the large student residence nearby.

A warm welcome is always on offer at this family-run establishment, with the bar area retaining the feel of a traditional local pub. A wide range of beers, spirits and wines are on offer, which can be enjoyed with the regular entertainment that is laid on. The New Inn also has a bit of a rarity among the St Andrews pubs in the form of a beer garden, which can be enjoyed throughout the summer months, along with food from the BBQ.

The Jigger Inn, Old Station Road
The Jigger Inn is probably the most remote pub in relation to the St Andrews town centre. It sits on the edge of the fairway of the 17th hole on the Old Course, and within

The front of the Jigger Inn.

sight of the iconic Swilcan Bridge. It is a favourite place for golfers and caddies to have a pint and a bite to eat, leading to it being known as St Andrews' favourite 19th hole.

The building itself dates back to the 1850s when it was the stationmaster's lodge for the former Links railway station. The railway station was lost in 1968 when the Old Course Hotel was built on the site, but the stationmaster's lodge remained, although it was now redundant, especially after the closure of the railway line to St Andrews in January 1969. Several years later, in 1974, the building was incorporated into the Old Course Hotel complex, and it was converted into a pub.

Externally the building remains as it was constructed, but internally it has been opened up to create the bar area, which is fitted out with booths around the outer walls where drinkers can enjoy a degree of privacy while still absorbing the pub's atmosphere. A large collection of antique golfing memorabilia is on display throughout, which, although interesting to look at and often the subject of conversation, are not overpowering and do not detract from the original character and charm of the property. One item on display is a Jigger Iron, a now obsolete club with a relatively vertical club head and a short shaft, from which the pub takes its name.

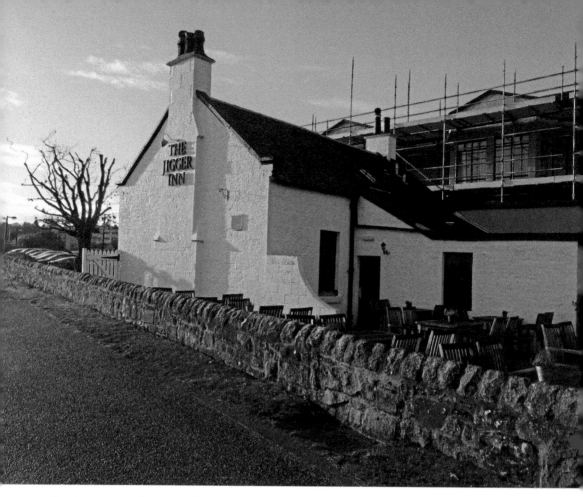

Seating area to the rear of the Jigger Inn.

The Jigger Inn is a regular haunt for the famous, particularly during the golf competitions at the Old Course. In 2010, the inn was rented by Andrew Chandler, a former golf professional turned director of a sports management company, during the Open Championship. The thinking behind renting the pub was to offer the players he represented and their families the facilities to have a meal without having to worry about making reservations in the town. Providing this relaxed atmosphere appears to have worked as the competition was won that year by Louis Oosthuizen, one of Chandler's clients, and his win was celebrated in the Jigger Inn. It is not, however, only the haunt of golfers, as in 2012 the national press reported that the former England cricket captain and keen golfer Michael Vaughan was due to play at the Alfred Dunhill Pro-Am Links Championship, but was offered a place in the television show *Strictly Come Dancing* and so could not attend. He was not forgotten, however, with golfer Paul Lawrie, American movie star Bill Murray, and fellow cricketer Andrew Strauss watching his performances from the comfort of the Jigger Inn.

The Jigger Inn sign.

Although the bar is small, a wide selection of Scottish beers are on offer, including the Jigger's very own 'Jigger ale'. In 2010, the Belhaven Brewery were approached by the owners of the Inn and asked to create a classic Scottish ale, which would only be sold in the inn. Today, the Jigger ale can only be bought at either the Jigger Inn or the Horse & Plough at The American Club in Kohler, USA. Anyone visiting can sample this unique ale, and you never know with whom you might be rubbing shoulders. On some occasions, you may find yourself in the company of indecisive golfers, thanks to a tradition known as the 'Pint per Stroke'. This challenge involves golfers making a quick visit to the Jigger Inn once they have completed the 17th hole and requires them to drink pints, with the challenge being to drink more pints than the number of strokes it will take them to finish their round of golf. Drink too few and you may lose the challenge by taking too many strokes on the tricky 18th hole, but drink too many and your game may be adversely effected. It is a fine judgement of alcohol verses accuracy, and with the 18th being a Par 4, only those that can hold their drink should attempt this custom.

The Road Hole Bar, Old Course Hotel, Old Station Road
The Road Hole Bar is not so well known among the locals of St Andrews as a place to go for a drink, but this relative newcomer to the list of the town's pubs is gaining a

The Old Course Hotel.

reputation for providing excellent service in the finest surroundings. The bar is based on the fourth floor of the iconic Old Course Hotel, a 5-star golf and spa resort usually considered a retreat for the rich and famous.

The Old Course Hotel first opened its doors in 1968, having been built on the site of the Links railway station on the rapidly failing railway line to St Andrews. Building a luxury hotel when one of the main transport links to the town was about to close may have appeared unusual, but the location is one of the most enviable in the town, and it is questionable whether the hotel would have developed into the impressive complex it is today had the railway line continued to pass directly in front of it. The hotel passed through several owners, each adding and developing the hotel to continue attracting the more affluent visitors to the town until 2004, when the current owners, the American investment company Kohler Co., purchased the hotel. Under their ownership, extensive redevelopment and extension work took place to create accommodation and facilities that are considered to be among the most luxurious in the world. In keeping with other projects the Kohler Co. have taken on in the town, facilities were also created that would be open to non-resident visitors and locals alike, and so the Road Hole Bar was opened.

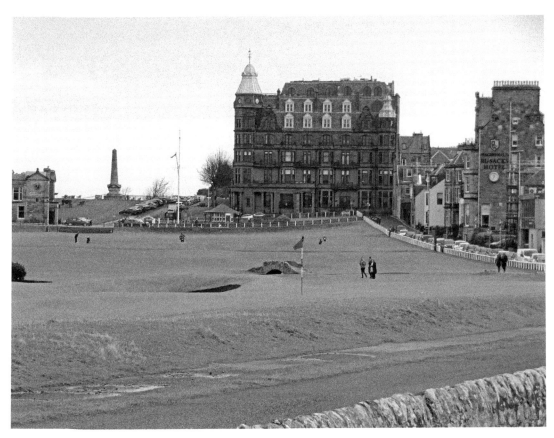

The Road Hole flag showing the hole beside the road.

The presentation of the bar reflects the quality of the remainder of the building, and so a smart-casual dress code is in place, yet it still offers warm and inviting atmosphere. Without a doubt the most impressive feature of the bar is the views. The hotel is directly adjacent to the fairway for the 17th hole of the Old Course, and provides unobstructed views from the bar across the 1st and 18th holes to the Royal & Ancient Golf Club and the Hamilton Grand, possibly the two most famous buildings in the golfing world. The hotel is so close to the fairway that part of the complex, known as the Black Sheds (see the section on Forgan's for more details) in fact partially obstructs the view between the 17th tee and hole. This, along with the hole being sandwiched between a road that marks out of bounds, and a notorious bunker, means that the 17th hole is deemed to be one of the most difficult of all the courses that host the British Open, and it is from this hole, better known as the Road Hole, that the bar takes its name.

Inside, the bar lays claim to having one of the widest selections of whisky available, which attracts whisky connoisseurs from all over the world. It offers a selection of over 300 blends, providing a whisky from every operational distillery in Scotland, and many distilleries that are no longer active, along with their own-label malt whisky. As with the Jigger Inn and the more traditional pubs discussed elsewhere in this book, the Road Hole is a firm favourite with golfers and celebrities and so you never know who you might bump into.